The Campus History Series

EASTERN KENTUCKY
UNIVERSITY
1957–2006

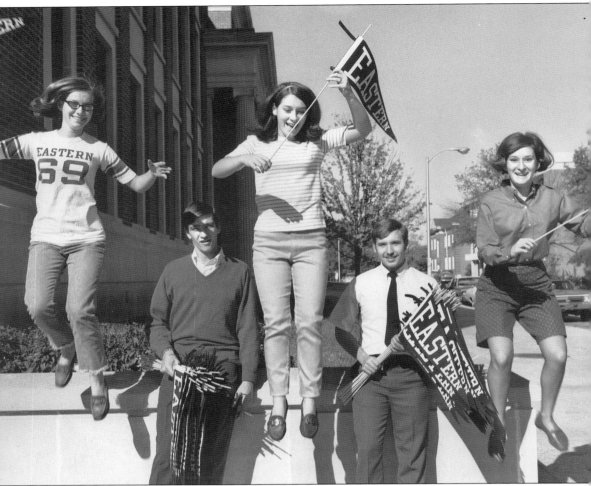

ON THE COVER: Students holding Eastern pennants jump in excitement for homecoming in 1968. The John Grant Crabbe Library is on the left directly behind the students. In the background on the other side of University Drive are the Cammack Building (left) and the Moore Science Building (right). (Courtesy of EKU Photograph Collection, Eastern Kentucky University, Richmond, Kentucky.)

The Campus History Series

EASTERN KENTUCKY UNIVERSITY 1957–2006

JACQUELINE COUTURE, DEBORAH WHALEN, AND CHUCK HILL

ARCADIA
PUBLISHING

Published by Arcadia Publishing
Charleston SC, Chicago IL, Portsmouth NH, San Francisco CA

Printed in the United States of America

Library of Congress Catalog Card Number: 2006932674

For all general information contact Arcadia Publishing at:
Telephone 843-853-2070
Fax 843-853-0044
E-mail sales@arcadiapublishing.com
For customer service and orders:
Toll-Free 1-888-313-2665

Visit us on the Internet at www.arcadiapublishing.com

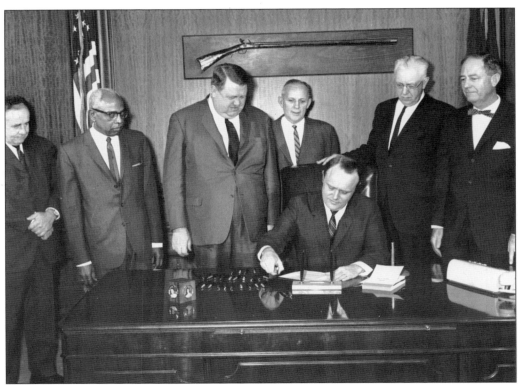

Signed into law on February 26, 1966, Kentucky House Bill 238 granted university status to Kentucky's regional colleges, effective July 1, 1966. On that date, Eastern Kentucky State College officially became Eastern Kentucky University. Pictured are Gov. Edward T. Breathitt (seated) and Pres. Robert R. Martin (third from left).

CONTENTS

ACKNOWLEDGMENTS

This is our second title with Arcadia Publishing, and once again, we would like to thank everyone we have worked with in getting this published. A special thank-you goes to Kendra L. Allen, acquisitions editor, who guided us through the first book and has worked with us again to complete the pictorial view of 100 years at Eastern Kentucky University (EKU). Our colleagues in the EKU Archives, Beth Cunningham and Joyce Miller, provided invaluable research assistance. A student assistant in the archives, Richard Garland, deserves special mention for his work in identifying and dating many of the images used in both books. Chris Radcliffe, university photographer, and Simon Gray, assistant athletic director for public relations, graciously provided the images from the past decade.

Again the extensive photographic material contained in the Eastern Kentucky University Archives was both a great help and a great hindrance. This time around, there were not only many thousands of print images to choose from but several hundred thousand negatives. Due to space restrictions, we were not able to fit in the many events and activities that could have been touched on. However, we feel that we have presented here an excellent sample of the rich and varied photographs that have come to our attention in the course of our work in the university archives.

In addition to the people mentioned above, we must express gratitude to the dean of the EKU Libraries, Carrie Cooper, for her support and encouragement of this project. We also must acknowledge the support we have received from various university offices and the people in them, including Joseph Foster, vice president for advancement; Marc Whitt, associate vice president for public relations and marketing; and Skip Daugherty, special events coordinator. A very special thank-you goes to EKU president Joanne Glasser, who graciously supplied us with "A Vision for the Future" to include in the text.

Unless otherwise indicated, all of the images in this publication are from the EKU Photograph Collection, Eastern Kentucky University, Richmond, Kentucky.

INTRODUCTION

With an enrollment now approaching 16,000, Eastern Kentucky University continues its 100-year tradition of serving eastern Kentucky and the Appalachian region. Founded in 1906 as Eastern Kentucky State Normal School, the educational roots of Eastern go back to 1874 when Central University was established because of a split in the Presbyterian Church. When Central University merged with Centre College in Danville in 1901, Walters Collegiate Institute took over the site and offered a classical college preparatory education to young men in Richmond and Madison County.

In 1906, the Kentucky General Assembly established two normal schools, one in the eastern district and the other in the western district, for the purpose of training teachers for the classroom, especially in the isolated rural areas of the state. The legislation, passed as the Normal School Bill (HB 112), also provided for the establishment of model training schools. A special commission decided to locate the schools in Bowling Green for the western district and Richmond for the eastern district. The Model Training School opened in September of that year, and the first training of teachers was begun in mid-January 1907.

In 1922, Eastern became a four-year institution known as the Eastern Kentucky State Normal School and Teachers College. The first degrees of this new entity were awarded in 1925. By 1926, the *Richmond Daily Register* estimated that Eastern generated nearly half a million dollars for the local economy. In 1928, the college was accredited by the Southern Association of Colleges and Secondary Schools. In 1930, the General Assembly abolished the normal school, and the school became Eastern Kentucky State Teachers College. In 1948, the General Assembly removed the word "Teachers" from the name of the college. Now known as Eastern Kentucky State College, it was granted the right to award nonprofessional degrees and non-teaching degrees. By the mid-1950s, Eastern began integration with the admission of a local high school teacher looking to complete a master's degree in education. Formal student government also came to campus in the 1950s.

In the 1960s, Eastern entered a period of unparalleled growth under the leadership of Pres. Robert R. Martin. A master politician and the only Eastern alumnus to serve as president, he had a vision of greatness for Eastern. Martin first focused his attention on a building program, especially on the need for dormitories to house an anticipated increase in the number of students. Soon 12 new dormitories, classroom facilities, physical education and athletic structures, a new student center, an experimental farm, several natural areas and recreational facilities, and other administrative and academic buildings came into existence.

Social fraternities and sororities were added in the 1960s. In October 1964, the Colonel made its debut as Eastern's official mascot. Martin turned his attention next to academic

development. In 1965, the institution underwent a major academic reorganization with the creation of five separate colleges and a graduate school. Gov. Edward Breathitt signed HB 238 into law on February 26, 1966, thereby granting university status to the state's regional colleges, effective July 1, 1966. After 1967, Eastern began offering a variety of master's degrees and a joint doctoral program in education with the University of Kentucky. Under Martin's leadership, there was growth in several innovative academic programs, notably in law enforcement and nursing. During Martin's tenure, Eastern's enrollment increased from 3,000 to 13,400 students.

Martin's legacy continued under his successor and longtime associate, Julius Cherry Powell, who became president in 1976. Powell devoted himself to strengthening the academic programs and to raising money from the private sector. The opening in 1979 of the Carl D. Perkins Building, which provided meeting space for conferences, and of the unique Hummel Planetarium signaled the school's growing commitment to public service.

President Powell was succeeded by Henry Hanly Funderburk in 1985. Enrollment under Funderburk's leadership surpassed the 16,000 mark, yet the institution faced several state budget cuts. In response to challenging economic times, Funderburk instituted strict fiscal management and major academic and administrative restructuring. Enrollment growth at Eastern reflected a national trend of more non-traditional students coming back to school for further educational advancement. Although some academic programs were cut back, new master's degree programs were initiated in criminal justice, occupational therapy, and nursing. Several building projects, including the Dizney Building, the Funderburk Building, and a major expansion of the Crabbe Library, were completed in the 1990s. Extended campus centers at Corbin, Manchester, and Danville were developed so that greater educational opportunities could be provided to people in Eastern's service region. By 1998, over 75,000 people had graduated from the university.

In 1998, Dr. Robert Walter Kustra assumed the presidency from Funderburk. He instituted a series of major academic and administrative reforms. The previous nine colleges were merged into five: Arts and Sciences, Health Sciences, Business and Technology, Justice and Safety, and Education. Kustra made a strong commitment to improving the quality of student life. "First Weekend" was instituted in an effort to provide social and cultural programs to keep students on campus during weekends. Construction began on a new student services building aimed at centralizing all student-related activities in one building. The Harry Moberly Wellness Building was dedicated in 2000.

Following Kustra's resignation, Eastern selected Joanne K. Glasser to be its 10th president in 2001. Under Glasser's administration, the university has demonstrated a dedication to serving its students and planning for their future needs, as seen with the openings of the Student Services Building in 2002 and the Student Fitness and Wellness Center in 2004. Recently the dedication of the new Business and Technology Center promises to offer even more opportunities for growth. Beginning with a few students engaged in short review and certificate courses, the university today serves thousands of Kentuckians. Eastern Kentucky University is a regional public institution of higher education that offers general and liberal arts programs and pre-professional and professional training in education and various other fields at both the undergraduate and graduate levels. Although Eastern has achieved a solid reputation as a comprehensive regional university, it still maintains its original commitment to providing a strong teacher training program.

One

BUILDING A UNIVERSITY

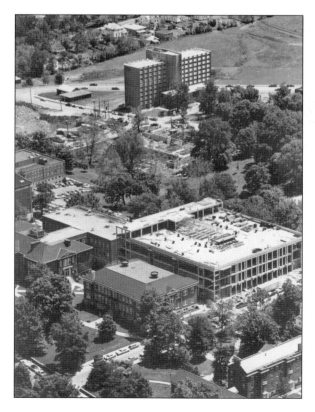

The Moore Science Building (front right), named after William J. Moore, an Eastern alumnus who taught economics for many years and later became dean of the college, is under construction in this 1967 photograph. Beyond the Moore Science Building and across the Ravine, construction on the Burrier Building is also underway. In the background is Walters Hall, a women's dormitory completed in 1967 and named for Singleton P. Walters, a founder of Central University.

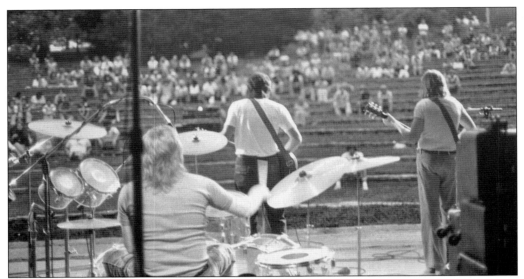

Since Eastern's beginnings in 1906, the Ravine has been a favorite spot for students to relax, socialize, and study. After the pavilion was built, the space was even better suited for concerts and performances, such as this 1977 Exile concert held as part of back-to-school activities. A local rock band, Exile made it big with the number-one hit "Kiss You All Over" before changing to a country format.

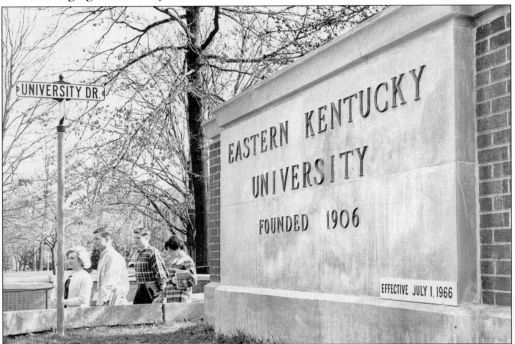

The sign on the corner of Lancaster Avenue and University Drive has long been a landmark welcoming visitors to campus. Shortly after the University Bill was signed in 1966, workers began changing this sign to read Eastern Kentucky University. University status became effective on July 1, 1966.

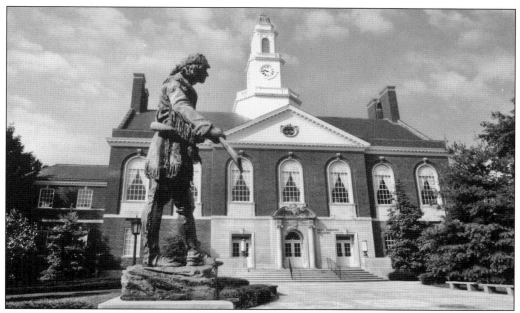

The Daniel Boone statue in front of the Keen Johnson Building is a replica of an Enid Yandell sculpture made for exhibit at the 1893 World's Fair. Originally sculpted in plaster, the statue was cast in bronze after the fair and presented to Yandell's home city of Louisville. With permission from Louisville officials, Eastern had a replica made and dedicated it on May 1, 1967. The bronze statue with base is nine feet high and weighs about 3,500 pounds. Students traditionally rub Boone's toe for good luck on tests.

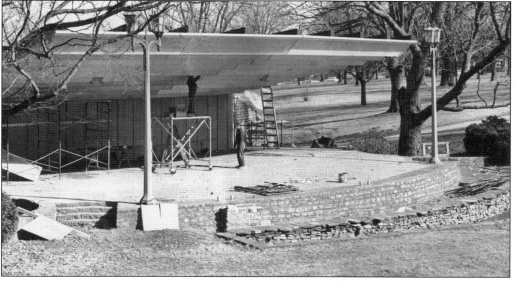

The Ravine's amphitheater, which has long been used for events such as summer commencement, dramatic performances, and concerts, was improved in 1962 with the addition of the Van Peursem Pavilion. Named after James Van Peursem, head of the Music Department for over 30 years, the pavilion includes lighting and acoustical facilities as well as dressing and storage rooms.

Several dormitories near Lancaster Avenue in 1961 included Miller, Beckham, and McCreary Halls (right foreground), Keith Hall (left background), and Memorial Hall Annex (right background). Demolished in 1962, Memorial Hall Annex was replaced with Earle Combs Hall, named after the New York Yankee center fielder and leadoff hitter who served as chair of Eastern's board of regents. Combs Hall was built as a men's dormitory with eight faculty apartments and is now used as a women's dormitory.

The Whalin Complex, named for longtime industrial arts professor and department chair Ralph Whalin, is comprised of the Fitzpatrick Building (middle right), which was built in 1939, and the Gibson and Ault Buildings, which are under construction in this 1962 image. The Gibson Building (middle left) honors Maude Gibson, an art professor for 33 years, and the Ault Building (far left) recognizes William A. Ault, the superintendent of buildings and grounds for 35 years.

This 1961 image shows some of the buildings that formed the core of campus. Facing Lancaster Avenue from left to right are the Coates Building, the Roark Building, and the Cammack Building. Immediately behind the Roark Building is the Memorial Science Building, which was built in 1952 and named in honor of Eastern students and faculty killed in World War II. Sullivan and Burnam Halls can be seen at the back of the photograph.

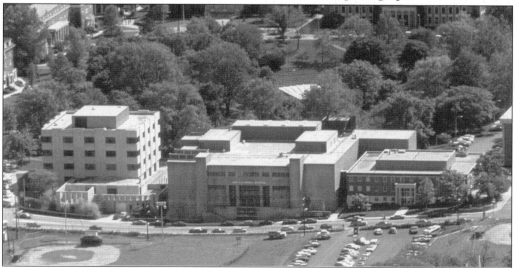

On the back side of the Ravine, facing Crabbe Street from left to right are the Burrier, Campbell, and Foster Buildings. Built in 1968, the Burrier Building is named for Mary K. Burrier, who served as the Home Economics Department chair. The Campbell Building, built in 1974 to house the Art Department, honors Jane Campbell, who arranged the music for Eastern's alma mater. The Foster Building was built in 1956 and named for Kentucky songwriter Stephen Collins Foster.

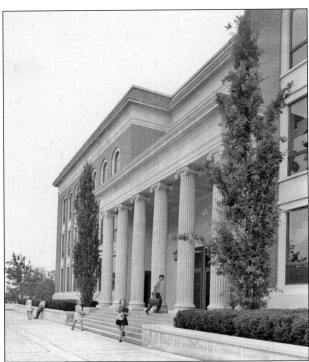

During the 1965–1966 academic year, the Crabbe Library holdings were moved to other locations around campus, and a $2.8-million renovation project was completed. Involving a new look for the front of the building, this renovation wrapped around the existing structure and added a floor, quadrupling the former space. This 1970 photograph shows the main entrance to the library on University Drive.

The University Building, built in 1874, was one of the original buildings that Eastern acquired from Central University. It has served many purposes over the years and is currently a classroom building on the first two floors and library stacks on the third and fourth floors. The hood molds above the windows were removed in 1962 but were replaced when the building was renovated in 1994.

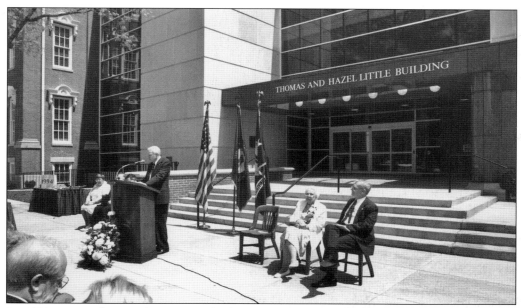

By 1990, it was obvious that Eastern had outgrown its library facilities, so a libraries capital improvement campaign raised $1.3 million to expand the building. The new Thomas and Hazel Little Building expanded the library space by 50 percent. Shown at the dedication of the new building in 1996 are, from left to right, library director Marcia Myers, Pres. Hanly Funderburk (speaking), Hazel Little, and James S. Chenault, chair of the capital campaign's volunteer committee.

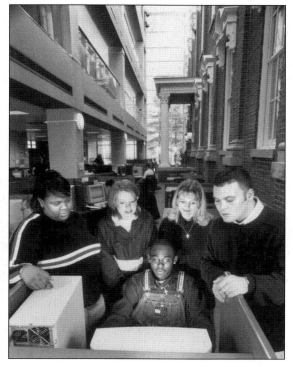

Due to space and budget restrictions and the desire to preserve the oldest building on campus, university officials decided to incorporate the University Building into the library expansion by wrapping the Little Building around it. This *c.* 2000 photograph shows the unique architecture of the old and new combined into an attractive skylighted space that now houses the Java City Library Café.

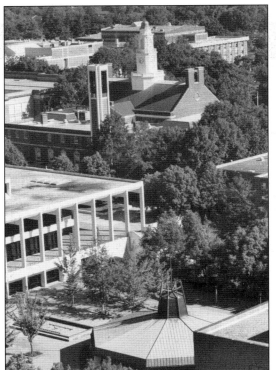

Sitting very near the center of campus, on the site of Hanger Stadium, is the octagonal-shaped Chapel of Meditation (right foreground). The Alumni Century Fund was created to raise funds for this nondenominational chapel, whose construction began in 1971. When the Powell Building (left foreground), named for Pres. J. C. Powell, was dedicated in 1971, the Memorial Bell Tower (left background) was played for the first time. The tower was the only cast-bell carillon in the state at that time.

The Smith Park Observatory was named for the first chair of the Physics Department, who served Eastern from 1923 to 1967. Dr. Park, pictured here, acquired the observatory dome and telescope from the University of Kentucky in 1964. The facility was used by classes until the university's lights made it impossible to see the nighttime sky. The building is now used for storage, and the telescope is in the lobby of the Hummel Planetarium.

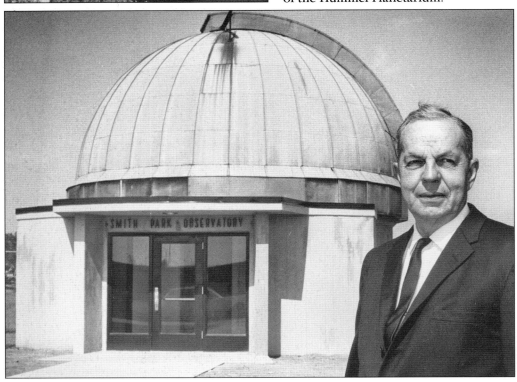

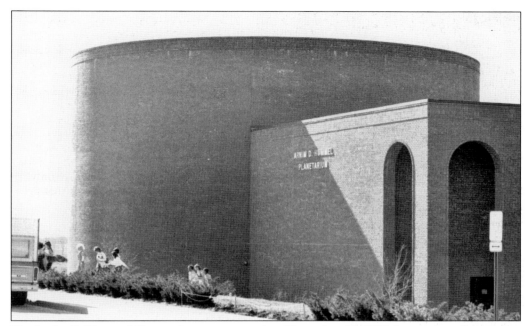

The Arnim D. Hummel Planetarium was opened on November 16, 1988. It contains a Spitz Space Voyager projection system under a 20.6-meter (67.5-foot) dome that is tilted at an angle of 27 degrees. The Hummel Planetarium is one of the largest and most sophisticated planetariums in the United States, especially on a university campus, with seating for 164 people.

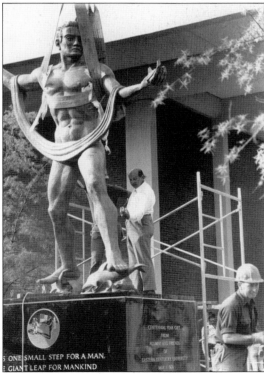

In 1974, the Alumni Association commissioned Felix de Weldon to create a statue celebrating the centennial of higher education at Eastern. The monument depicts a man using his arms to launch the *Saturn* rocket into orbit. De Weldon, standing next to the statue during its installation, wanted it to symbolize the research of scientists, the people working for the space program, and the support of the American people for these efforts.

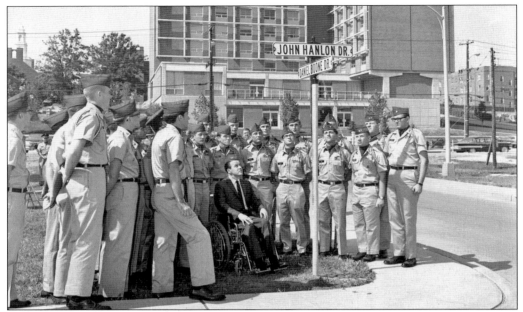

Eastern honored alumnus John Hanlon by naming a street after him in 1968. Hanlon was a Vietnam War veteran who received a Silver Star for gallantry in action during a clear and hold operation in which he was paralyzed from the waist down. Daniel Boone Drive was renamed in 1970 in honor of Paul Edwin Van Hoose, the first Eastern ROTC (Reserve Officers Training Corps) graduate killed in Vietnam.

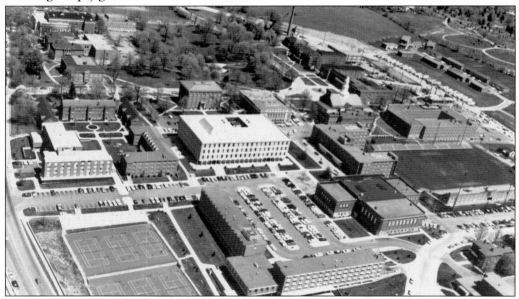

Completed in 1962, Martin Hall, shown to the right of the tennis courts, is a men's dormitory named after Pres. Robert R. Martin. Buildings across the parking lot from the tennis courts are, from left to right, Earle Combs Hall, Keith Hall, and the Bert Combs Building. Named for a Kentucky governor, the Bert Combs Building was completed in 1964 to house the education and business departments. (Jimmy Taylor Photographs, EKU Archives.)

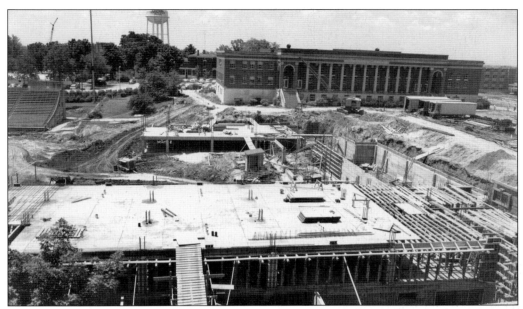

With a 320-percent growth in enrollment between 1953 and 1963, Eastern's physical plant also increased tremendously. Seen under construction is McGregor Hall, a six-story women's dormitory named after Regent Thomas B. McGregor. McGregor Hall and Earle Combs Hall were the first dormitories to have air conditioning. In the background are Hanger Stadium (left) and the Weaver Building (right). (Jimmy Taylor Photographs, EKU Archives.)

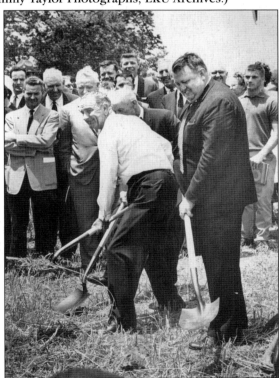

June 1, 1961, was proclaimed Lyndon B. Johnson Day in Richmond. On this day, the vice president visited Eastern as the commencement speaker and received the first honorary degree ever awarded by the college. Commencement was followed by a groundbreaking ceremony for the Alumni Coliseum and a parade in downtown Richmond. Seen breaking ground are Johnson (left) and Pres. Robert R. Martin (right).

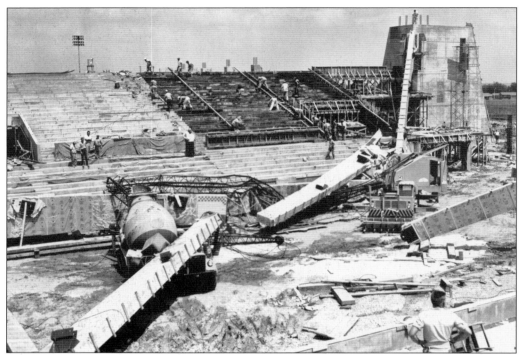

On August 14, 1962, during construction of the Alumni Coliseum, the failure of the cables holding the main support beams caused them to collapse. Two workers were injured, a section of seats was demolished, equipment was damaged, and completion of the building was delayed while new beams were ordered and the damage was repaired.

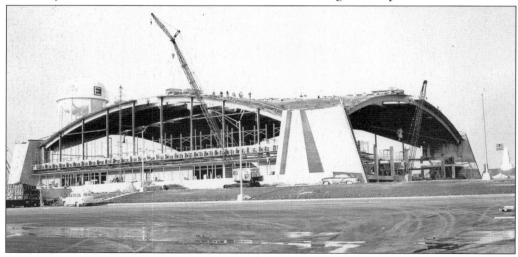

Built on the site of Eastern's dairy farm and completed in 1963, the Alumni Coliseum had the world's largest laminated wood roof. The building contained a main basketball arena seating 6,500, four additional basketball courts, indoor and outdoor swimming pools, locker rooms, offices, and classrooms. In 1989, the main basketball arena was named for Paul S. McBrayer, Eastern's basketball coach from 1946 to 1962, who holds the record for the most wins in EKU basketball history.

Hanger Stadium served Eastern's football team until 1968 when it was demolished. This 1965 photograph shows the new women's dormitories of Case Hall (left foreground), named after Dean of Women Emma Case, and McGregor Hall (right background). The Keen Johnson Building (right foreground), which houses the University Bookstore and the Teaching and Learning Center, is still used for dances, receptions, and banquets. Palmer, Dupree, and Todd Halls are in the background from left to right.

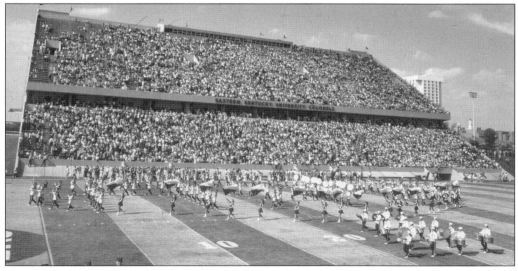

The Begley Building, named after Regent Robert B. Begley, was completed in 1970. It includes the football stadium, named for longtime football coach Roy Kidd, classrooms, offices, basketball and racquetball courts, as well as locker room and training areas. At the time it was built, the state legislature would not approve university stadium facilities, so Pres. Robert R. Martin's proposal was for a classroom facility with a stadium attached.

Faced with a large housing shortage in the 1960s, Eastern built Commonwealth Hall (left), a 21-story men's dormitory, which is still the tallest building on campus, visible from miles away. The other three dormitories are, from left to right, Palmer Hall, named after Regent Wilson Palmer, and Dupree and Todd Halls, twin buildings. These three were originally for men but are now coeducational. Alumni Coliseum can be seen in the background.

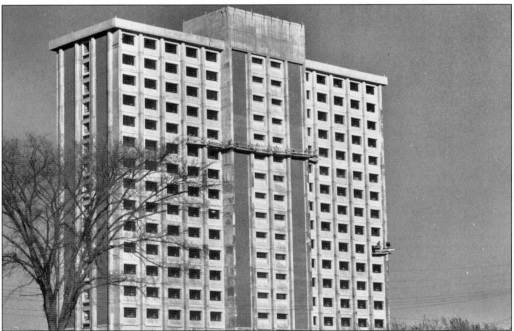

Between 1959 and 1969, Eastern built nine men's dormitories and five women's dormitories. These 14 buildings, plus Sullivan and Burnam Halls, still serve all of Eastern's on-campus residents. Shown in this 1968 photograph is the nearly complete Keene Hall, named for English professor William Keene.

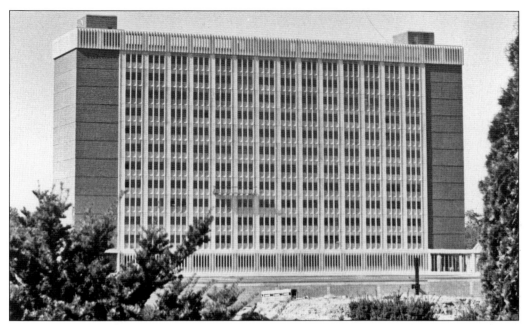

Telford Hall, a women's dormitory named after music faculty member Brown E. Telford, was occupied for the first time in 1969. The suite-styled rooms feature an adjoining bath shared by four women. Both Telford Hall and Keene Hall were originally planned as dormitory complexes with three additional buildings and a large cafeteria at each location.

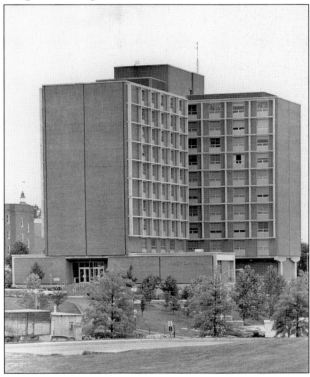

Clay Hall was built as a women's dormitory in 1966. Named after Regent Sidney Clay, it has been changed to a coeducational dormitory in recent years. Coeducational dormitories typically have alternating men's and women's floors. Gone are the days of limited visiting hours and other restrictions. Students were allowed to have refrigerators in 1972 and cooking appliances, such as microwaves and coffee pots, in 1986.

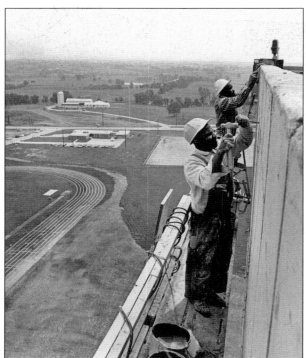

These two workers at the top of Commonwealth Hall have a view of the surrounding countryside in 1967. Beyond the track (front left) are the state police post and the Stateland Dairy Center, which is across the Eastern Bypass. When Eastern started building beyond the dairy, Kit Carson Drive, which stops at the Eastern Bypass in this photograph, was extended to the south side of campus.

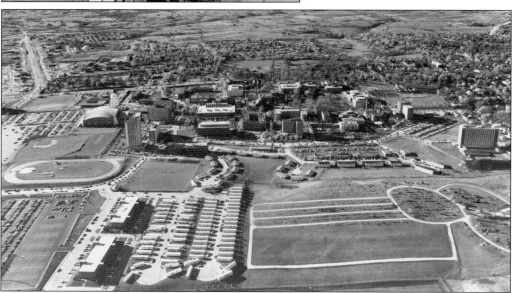

Houses, mobile homes, and apartments were gradually added to the campus to meet the needs of married and non-traditional students. Next to the Richmond Cemetery (front right), Brockton Family Housing (back right) honors G. M. Brock, who served in various business-related capacities for Eastern from 1918 to 1969. Adjacent to the mobile home park (front left) are two apartment buildings named after Henry Martin and Fred E. Bishop. The Tom C. Samuels Track and the "Turkey" Hughes Baseball Field (back left) are also visible in this 1976 photograph.

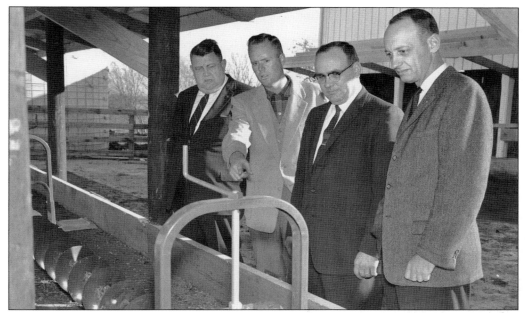

Eastern completed a new, state-of-the-art dairy facility for their prize Holstein herd in 1961. Located a quarter-mile south of the original farm, this barn featured an automated feeding system, which is being explained by agriculture professor Jackson Taylor, and a milking parlor with pipelines, so that the milk was never handled. From left to right are Pres. Robert R. Martin, Taylor, William Householder, and dean of business affairs J. C. Powell, who later became Eastern's seventh president.

Meadowbrook Farm was acquired by Eastern in 1973 to enhance the agriculture curriculum. The 720-acre farm, located 10 miles east of campus, gives students practical lessons in herd management of cattle, swine, and sheep, as well as various crop enterprises. This photograph shows the new dairy facility, which was moved from the main campus in 1995. The cover on the mineral feeder (front right) protects the feed from rain.

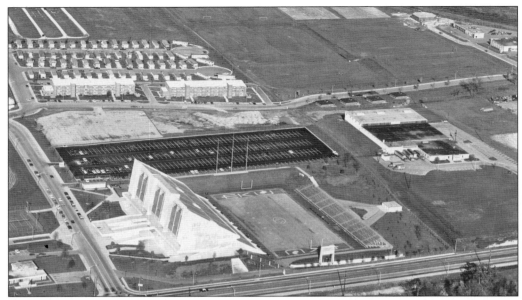

Beyond the Begley Building (front left) are the McDonough Intramural Fields and the Donaldson Complex (back right), named for a former business affairs vice president. This complex is composed of the Black Building, a mechanical services structure named for John Black, who served the buildings and grounds division for 39 years; the Frank C. Gentry Building, a shop facility named for the first buildings and grounds superintendent; and the Larry O. Martin Building, a storage warehouse named for a food services director.

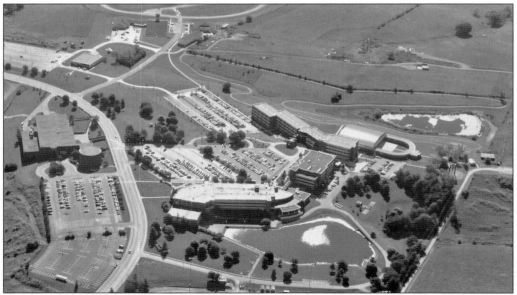

In 1975, the Martin Law Enforcement Complex (front right) began with the Stratton Building, named for Regent Henry Stratton, and the Leslie Leach Driving Range. In conjunction with the Department of Criminal Justice Training, a state agency, the facility has expanded to include a pursuit course, firing range, dormitory, indoor track, and offices. The Ashland, Inc. Building (back left) houses the Fire and Safety Engineering Technology Program.

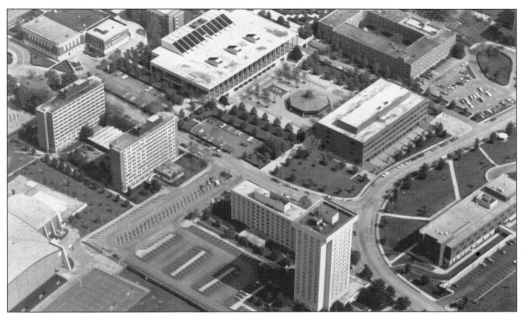

This 1978 aerial view shows the Wallace Building (back right) by the Chapel of Meditation. Named after Regent William L. Wallace, this building houses the English, mathematics, computer science, and special education departments. Directly across Kit Carson Drive is the John Rowlett Building (front right), named after the vice president for academic affairs and research, which houses Student Health Services and the nursing programs. In 1992, the Dizney Building was built behind the Rowlett Building to provide additional space for the rapidly growing College of Allied Health and Nursing.

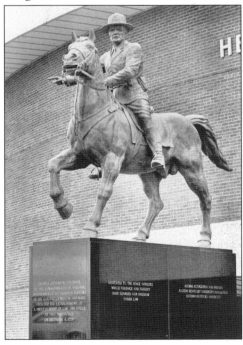

Felix de Weldon was commissioned to create this equestrian statue in front of the Stratton Building in 1974. The statue symbolizes the prominent position that Eastern's law enforcement program has in the nation. The actual depiction is of a mounted Kentucky state trooper, and even though Kentucky state police officers never rode horses, other early peace officers often did.

Ellendale Hall, also known as Stateland Hall, was purchased with the Gibson Farm in 1922. Serving as a dormitory and as home to the counseling center, it was demolished in 2000 for the construction of the Student Services Building. Behind Ellendale Hall are Dupree Hall (left), named after Regent F. L. Dupree, and Todd Hall (right), named after Regent Russell I. Todd. Both were built in 1964 as men's dormitories.

Completed in 2002, the Student Services Building is a five-story complex that houses a wide range of offices designed to offer students one place for all their administrative needs. The building also includes the 400-seat multipurpose O'Donnell Auditorium, a state-of-the-art video conference room, a computer laboratory, a computer store, and classrooms. (Courtesy of C. Richard Garland.)

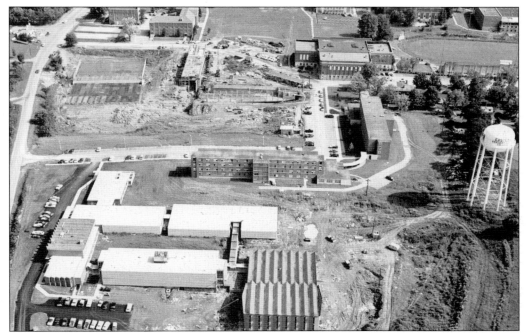

Eastern's building boom of the 1960s actually started in 1959 with O'Donnell Hall. Named after Pres. William F. O'Donnell, it is situated northwest of the water tower, on the current site of the Student Services Building. Adjacent to O'Donnell Hall and built in 1960, Mattox Hall (center) was named after registrar and professor Melvin E. Mattox. Built as a men's dormitory, it now serves as office space. This 1962 photograph also shows the Model Laboratory School complex (front left), along with the construction of the tennis courts and Martin Hall (back left).

In 2006, the new Business and Technology Center opened across the Eastern Bypass from the Alumni Coliseum. This state-of-the-art classroom is a three-story building featuring a skylight-covered atrium, a 120-seat auditorium, 20 classrooms, and 5 computer laboratories. Phase II of its construction will include a conferencing center and a 2,000-seat performing arts theater.

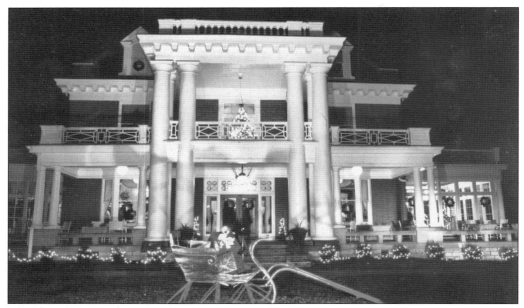

Arlington was donated to Eastern Kentucky University and the EKU Foundation in 1967 through a bequest from William Arnold Hanger. Decorated for the holidays *c.* 2000, the mansion with its fine dining is the focal point of the estate. The Mulebarn, located behind the mansion, contains a 16-foot fireplace, a stage area for bands, and a large dance floor.

The Arlington estate includes a swimming pool, a wading pool, an 18-hole golf course, and tennis courts, as seen in this photograph. The par-72 golf course takes advantage of the estate's natural contours and lakes to make a home for Eastern's golf teams. The Arlington golf course, a nationally accredited business program, and a turf grass management program enabled Eastern to establish Kentucky's first PGA/Professional Golf Management Program in 2006.

The amphitheater seating in the Ravine, built in 1935 with a Works Progress Administration grant, is such a landmark on campus that it was used in the centennial logo. Students take advantage of the area to study and socialize between classes in this 1982 photograph. (Donald Wallbaum Negatives, EKU Archives.)

Eastern rarely closes for snow, but an 18-inch snowfall in 1978 caused registration and classes to be cancelled for a short time. The campus erupted in a free-for-all snowball fight, causing several windows to be broken and the threat of arrest for students throwing snowballs at buildings and cars. Several students used their excess energy creatively and sculpted a seven-foot-high sphinx in the Ravine. This photograph shows the back of the Coates Building (left) and the side of Blanton House (right).

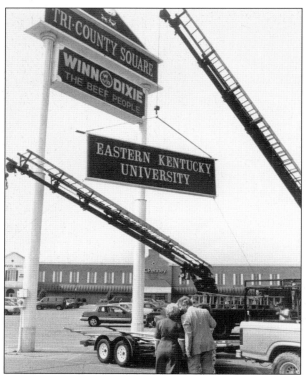

Eastern offers classes at campuses in Danville, Manchester, and Corbin to meet the educational needs of students in its service region. The first of these extended campuses opened in Corbin in 1990 in a vacant storefront, shown in this photograph. Classes were offered in Manchester in 1992, in Danville in 1994, and in Somerset, Fort Knox, Hazard, and Lancaster in more recent years.

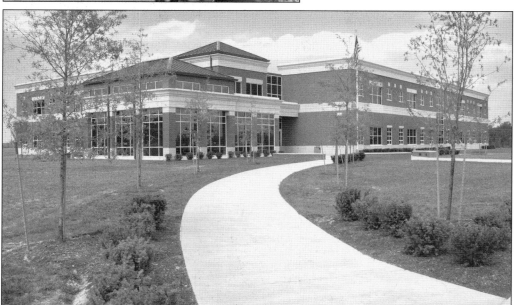

Offering over 400 graduate and undergraduate classes each year, the extended campus in Corbin is the largest and the newest. Completed in 2004, the building provides 26 classrooms, 2 science laboratories, and 3 computer laboratories. A basic reference book collection and a state-of-the-art computer system link the Corbin campus to the main library in Richmond to provide students with expanded library services.

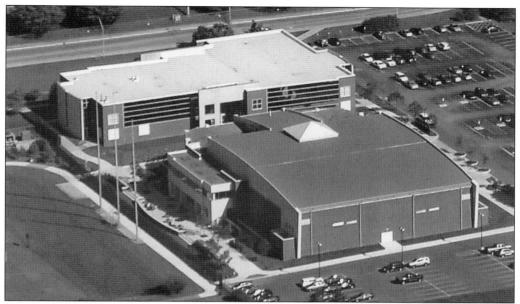

The Fitness and Wellness Center (foreground), completed in 2004, features a weight and fitness area that includes the latest in exercise equipment, a four-lane indoor track, a multi-purpose gymnasium, a group exercise room, and locker and shower facilities. The Harry Moberly Building (background) is designed to meet the needs of Eastern's intercollegiate athletic program and the exercise and sports science academic program. Completed in 1999, the building is named to honor a former EKU athlete and active supporter of Eastern athletics.

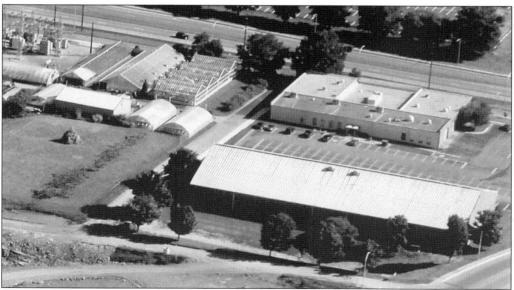

The Greg Adams Building (front right) is named for Gregory Sullivan Adams, a former EKU student. Constructed in 1977, it contains four indoor tennis courts, lockers, and a viewing deck. The Carter Building (back right) is named for agriculture professor Ashby Carter, and the greenhouses (back left) provide practical experience for horticulture students.

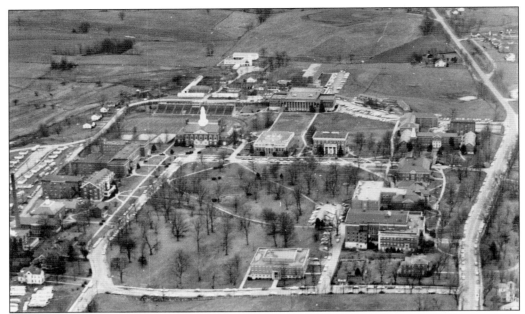

This aerial view of Eastern's campus was taken in early 1960 just before the building boom of the Pres. Robert R. Martin era. Although some of the buildings around University Drive and the Ravine have been modified, all of them are standing today. The university farm (back left) is situated behind Hanger Stadium, and the baseball field (back right) had recently been moved in 1958.

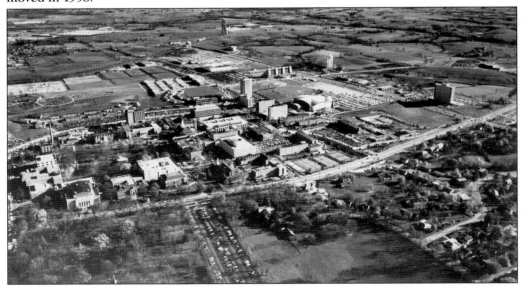

In Pres. Robert R. Martin's 1960 inaugural speech, entitled "A Vision of Greatness," he predicted the growth of Eastern. As seen in this photograph from 1976, the actual growth of facilities and programs during his 16-year administration surpassed even his vision. By the end of Martin's first decade, the dollar value of the campus had increased seven times, and the physical size had quadrupled, causing some to say that the 1960s was the most significant decade in the university's development.

Two

ACADEMICS

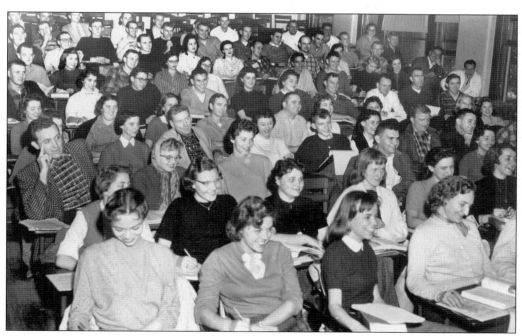

Students in a 1958–1959 psychology class laugh as Prof. William Sprague practices his theory that learning can be fun. Psychology courses were first offered as a part of the education curriculum, and in 1965, the curriculum had expanded enough to offer a minor. A major in psychology was offered in the 1966-1967 catalog.

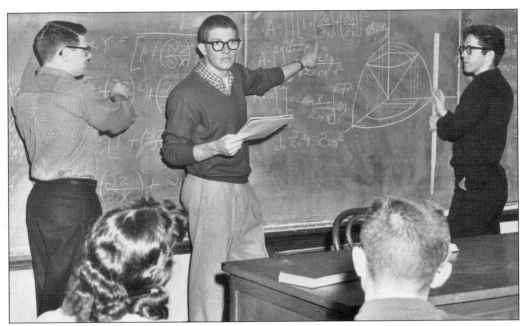

The Mathematics Department was established early in Eastern's history, and majors were offered by the 1930s. By 1946, general education requirements in mathematics were dropped; however, many majors still require certain mathematics classes for graduation. These 1959 students work complicated problems on the chalkboard.

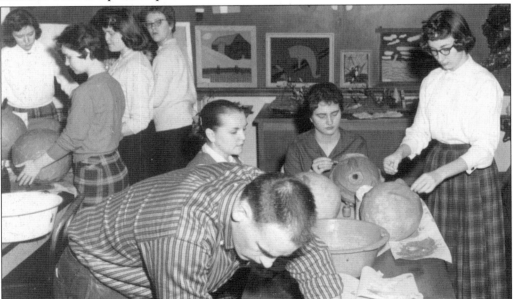

Pictured here is an art class from 1959. The art curriculum at Eastern was initially aimed at teacher education and as electives for those students with creative inclinations. It was not until 1971 that a bachelor of fine arts (BFA) degree was offered in painting and sculpture. Other areas, such as jewelry, ceramics, and photography, were added later. The program now offers a BFA in seven areas and a bachelor of arts degree in art education and art history.

Pat Kelly (right) and Peggy Parker (left) work on experiments in the laboratory in 1958. The science department at Eastern had a very slow start. Until 1924, all courses were taught by a single professor, and all were treated as general science. Since then, the program has grown and split into several departments, including chemistry, physics and astronomy, biological sciences, and earth sciences, offering numerous degree programs.

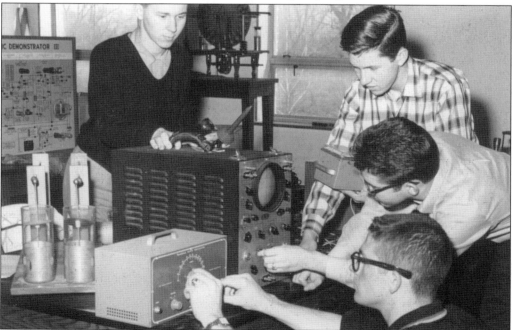

The industrial arts department added a technical department in 1953–1954 for students who did not want to teach but instead wanted to enter industry. At the same time, the electrical area was expanded. These 1958 students are working with an oscillograph, an instrument for measuring alternating or varying electric current in terms of current and voltage.

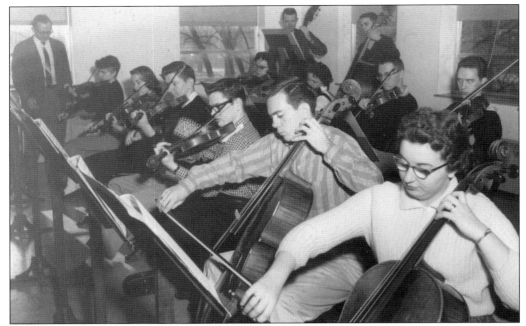

Like art, music was considered an extracurricular activity in the first decades of the college. It was not until 1966 that a bachelor of music degree was offered. However, even without a music major, the Music Department was one of the strongest on campus, and many classes were offered, such as this strings class taught by Prof. Robert Oppelt (left) in 1958.

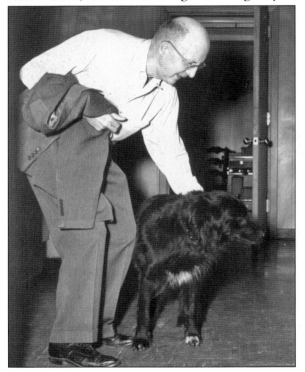

James Van Peursem, music faculty member for 35 years and head of the department for 30 years, pets Mozart the dog, the college mascot in the 1950s and 1960s. Mozart was regularly seen attending classes, football games, and musical events on campus. He is buried in the Ravine, behind the Van Peursem Pavilion.

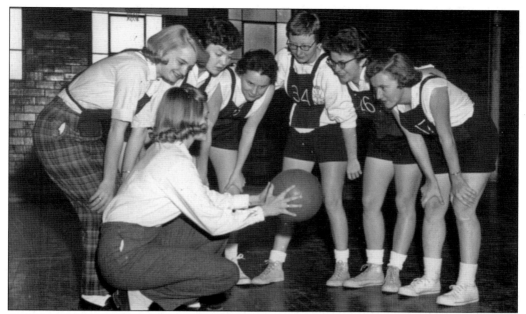

Carol Kidd (front) teaches a physical education class in basketball in 1958–1959. The importance of exercise was recognized in the earliest days of Eastern, and physical education classes were required for all students as early as 1910. Now known as the Department of Exercise and Sport Science, students are prepared for both teaching and non-teaching positions in this field.

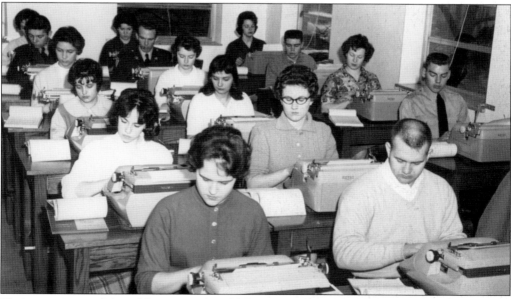

The expansion in the world economy resulted in the expansion of the Commerce Department. These 1962 typing students are using top-of-the-line manual typewriters. From a department offering three degrees in 1962 to the nationally accredited College of Business and Technology offering two- and four-year degrees and minors in many fields in 2006, this area of study has really grown.

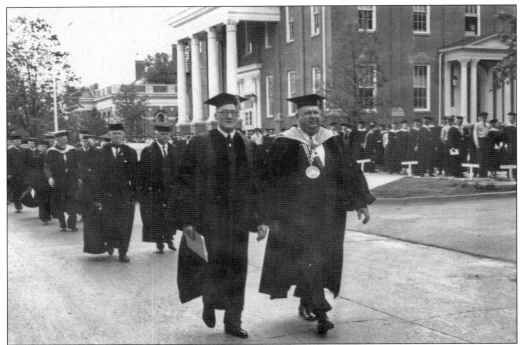

Eastern's president, Robert R. Martin (right), and Sen. John Sherman Cooper (left) led the academic procession at spring commencement in 1962, at which 475 degrees were awarded. In comparison, Eastern conferred nearly 1,500 degrees in May 2006.

These students use the Crabbe Library's Grand Reading Room to study in 1965. After the library renovation, this room was used as the circulation area, and one end was filled with card catalog cabinets. After the Little Building addition in 1994, the circulation desk was moved into the new addition, and the Grand Reading Room was restored to a study area.

Heasun Kim (left) and Marianthi Coroneau (right) both earned a master's degree in education in 1963. The graduate program was initially planned to meet the needs of teachers and other education professionals. It was not until 1966 that Eastern began to offer master's degree programs in non-teaching areas.

Nursing Department chair Bertha J. Fanjoy discusses training with Jackie Wells and Mary Anne Holland, students in Eastern's first nursing class. From left to right are Fanjoy, Wells, Holland, and Pres. Robert R. Martin. The nursing school opened in the fall of 1965 with the chair, 2 instructors, and 23 students. The only program offered was a two-year associate degree. By 1975, the program had expanded to the point that the College of Allied Health and Nursing was established. The program remains one of Eastern's strongest.

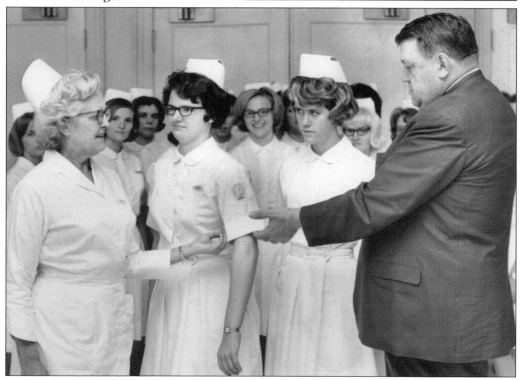

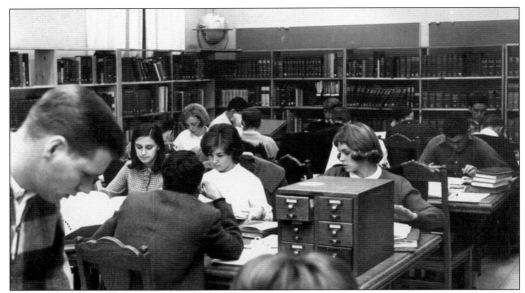

Before the 1965 renovation of Crabbe Library, administrative offices and the main library book collection were relocated to the basement of Case Hall. All other library departments, such as periodicals, reference, and the Kentucky Room, were moved to the first floor of the Combs Building. In this photograph of the temporary reference room, chalkboards can be seen behind the bookshelves.

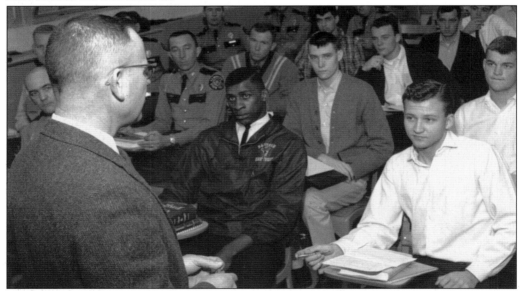

Under Pres. Robert R. Martin's leadership, Eastern established the first law enforcement training program in the state. The newly developed program served law enforcement officers as well as traditional students, as seen in this 1966 photograph. The first degree offered was an associate degree for police officers. The program now offers bachelor's degrees in corrections, assets protection, fire science, emergency medical care, and others. The master's program in loss prevention and safety, taught through the Kentucky Virtual University, is the first full-degree program offered online.

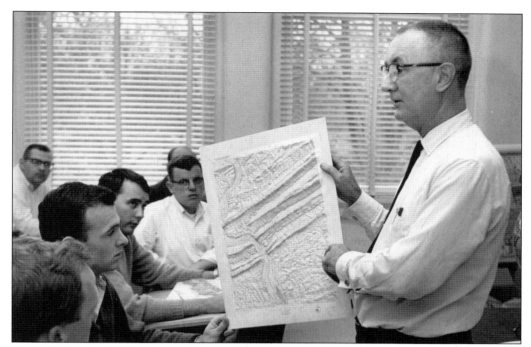

A National Science Foundation grant in the spring of 1965 provided funds to purchase instructional materials and equipment for the geography and geology departments. Prof. Robert Lathrop (right) uses some of these materials while teaching an advanced geography class in the 1965–1966 school year.

In the 1965–1966 school year, Eastern's Department of Education had 456 students in the teacher education program. Student teaching was, and still is, a requirement for graduation. The students spend 12 weeks in a practical classroom situation under the supervision of an experienced teacher. They write lesson plans, develop visual aids, evaluate student work, and teach classes.

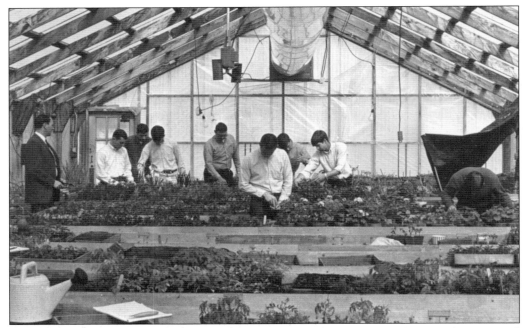

The horticulture curriculum is enhanced by practical experience in the greenhouse. Prof. Sam E. Whitaker (left) watches students work in 1967. Today several greenhouses provide students with experience in cultivating poinsettias, bedding plants, and perennials.

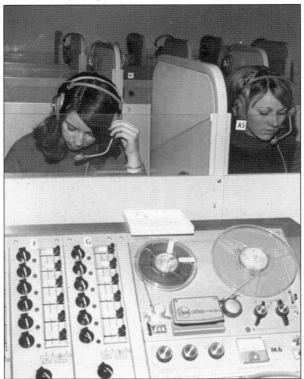

The foreign language program in the 1960s offered courses in French, German, Greek, Latin, Russian, and Spanish. A listening laboratory was available to help students with pronunciation and accent, as seen in this 1969 photograph. As a sign of the times, today's language offerings include Japanese and Arabic. Greek and Russian are no longer offered.

The food and nutrition laboratories in the Burrier Building are equipped to support undergraduate and graduate courses, such as experimental foods, quantity food production, community nutrition, and foodservice organization and management. These 1967 students put the final touches on a dessert made in the new food laboratories.

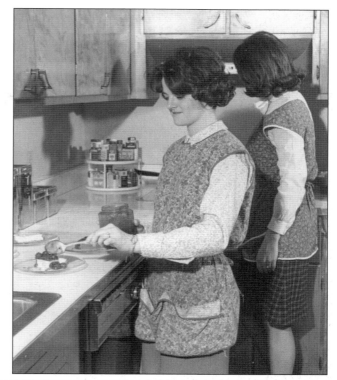

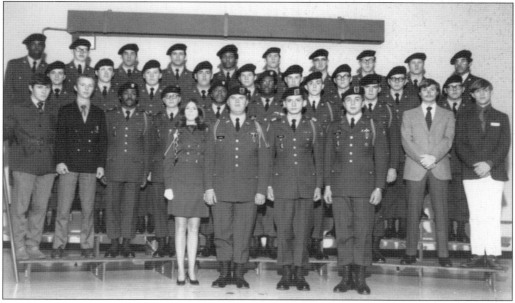

The Counter Guerilla Raider Company was designed to give junior and senior ROTC cadets training in preparation for summer camps. Its goal was to familiarize the cadets with the rigorous training that special forces receive. These 1970 raiders were able to participate in activities such as rappelling and hand-to-hand combat, while other military units on campus were not.

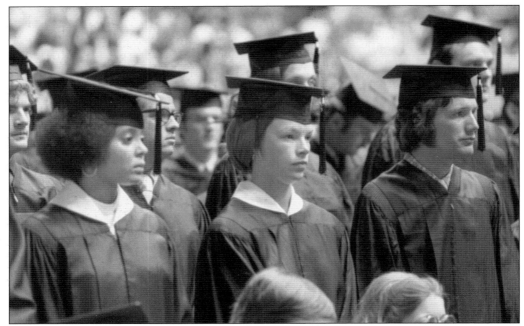

Waiting in Alumni Coliseum to receive diplomas during the spring 1973 commencement are, from left to right, Jennie Alcorn, Judy Alderson, and Larry Allen. Wendell Ford, Pauline Knapp, and Harland Sanders received honorary degrees during this commencement.

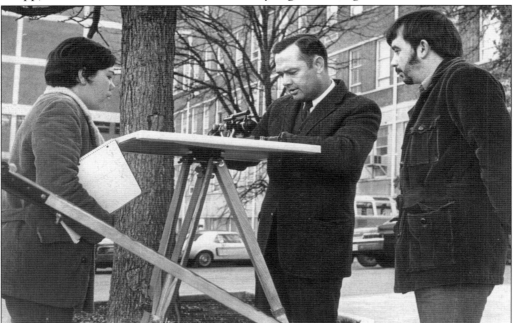

Jane Woods (left) and Dick Walker (right), members of Prof. William Adams's 1970 field geography class, learn to make a map using a telescopic alidade mounted on a plane table. The object is sighted through the alidade and drawn onto a sheet of paper attached to the table.

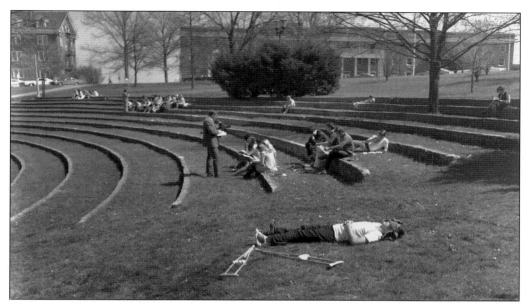

When the weather warms up in the spring, it is common to see professors holding their classes in the Ravine, as in this 1971 photograph. Art, biology, and horticulture classes regularly use the Ravine as a part of their course work, using the beauty and numerous varieties of plants that are found there.

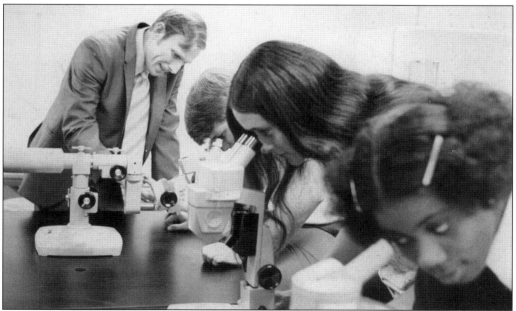

Giles Black (left) instructs students in a criminalistics laboratory. These students are, from left to right, William Gootee, Pamela Smith, and Cheryl Kennedy. When this photograph was taken in 1972, the law enforcement program had expanded from one class in 1966 to 41 courses. The faculty had expanded from 1 part-time instructor to 14 full-time faculty members. In addition, ground was broken this year for a new law enforcement traffic safety center to hold the rapidly expanding program.

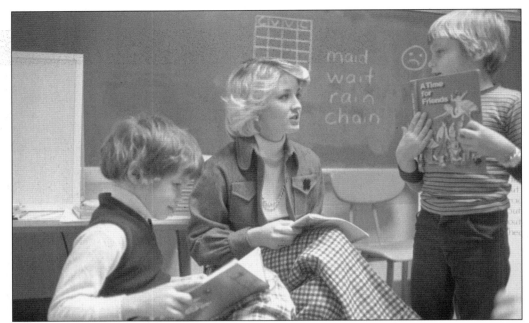

This photograph shows a student teacher working with two children on a reading lesson in 1975. The College of Education offers degree programs for all aspects of the school system, from regular classroom teachers to special education teachers to school counselors to principals. The interpreter training program has also expanded to a four-year degree in recent years. An extensive master's degree program is also offered to serve the needs of Kentucky's educators.

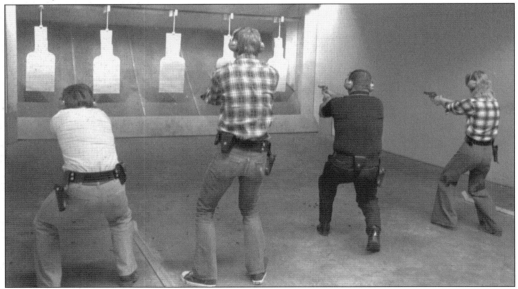

These students in 1976 take aim at targets in the indoor firing range of the newly opened Robert R. Martin Law Enforcement Center. The College of Law Enforcement moved into their new offices in August 1975, a year after they were established as a college. This college grew from 47 students in 1966 to 2,300 students at the time they moved into the new center.

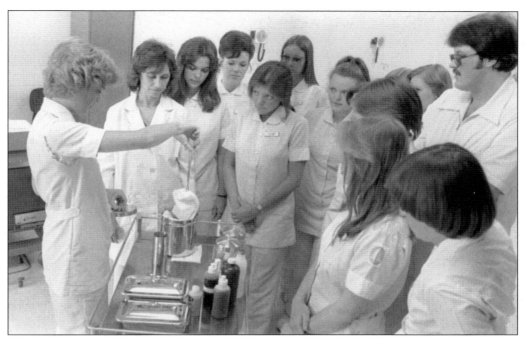

The Department of Associate Degree Nursing, established in 1965, prepares a graduate to function as a generalist registered nurse, practicing in a variety of positions in a variety of clinical settings. This associate degree nursing class from 1977 observes a demonstration. In 1995, a master's of science in nursing was implemented, and in 1999, the College of Allied Health and Nursing was renamed the College of Health Sciences.

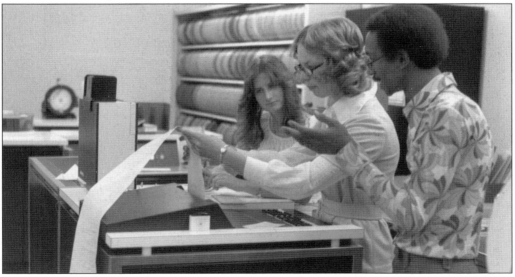

The world of computers has changed considerably since this 1975 photograph of the data processing room. As technology has advanced, Eastern has seen major changes in the computer science curriculum. In 1999, the program moved from under the umbrella of the Mathematics Department, and a new Department of Computer Science was created. A master's degree program has recently been established as well.

The Emergency Medical Care (EMC) Program was initially established in the College of Allied Health and Nursing but was moved to the College of Justice and Safety because many firefighters cross-train as paramedics. Eastern's EMC program is the only accredited paramedic program in Kentucky. These 1977 students are practicing their vehicle extrication skills in a classroom simulation.

These 1977 occupational therapy students demonstrate the use of special tools to aid patients in feeding themselves. The Department of Occupational Therapy was established in 1976 and offers a continuum of degree programs from a bachelor's degree to a doctoral degree in rehabilitation sciences, in collaboration with the University of Kentucky.

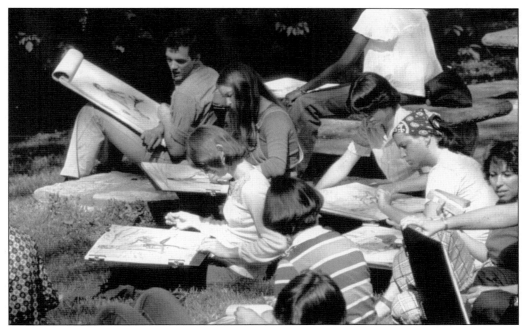

Eastern students are encouraged to actively participate in activities outside the classroom. Like many students before them, these 1978 art students are taking advantage of the Ravine for class assignments. A student does not have to be an art major to take a painting class. Painting is one of the many classes that can be taken for self-expression or personal enjoyment.

Students in a 1978 real estate class are comparing housing prices in a number of cities in Kentucky. They are using a teletype machine to access the data. Today's students can get a minor or certificate in real estate or a degree in finance with an option in real estate.

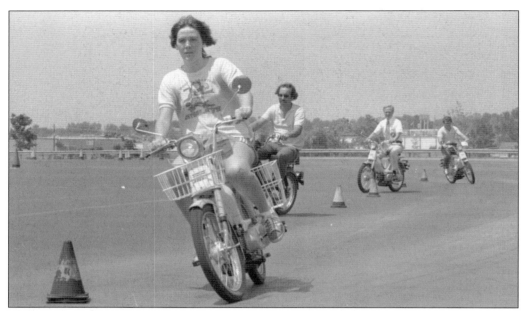

The Traffic Safety Institute was established at Eastern in 1967 as a direct result of the federal Highway Safety Act in 1966. The Leslie Leach Driving Range in this photograph was named after the first director of the institute. These 1978 students are taking a moped clinic, which was just one of the course offerings at the time.

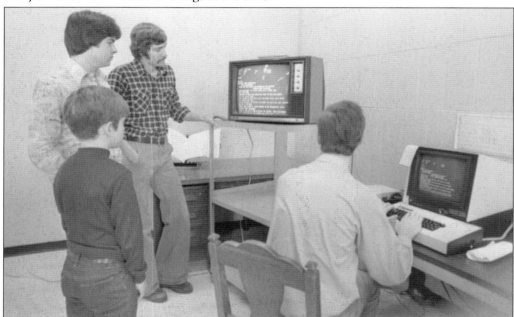

In the early days of computers, the Division of Academic Computing used television screen display terminals for instructional purposes. This 1979 photograph shows a computer being used to find information about tiger salamanders for a biology class. Professors in 2006 use projectors that have the advantage of being visible to a larger number of students, as well as having a much larger graphic content.

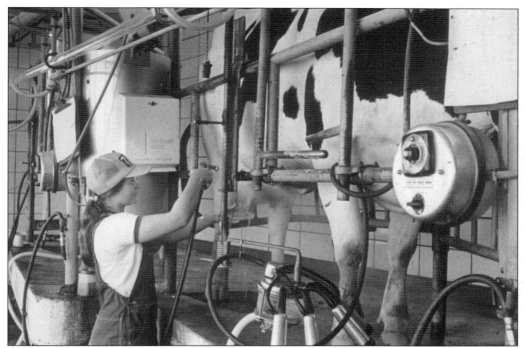

Dairy herd management is just one of the degrees available to Eastern agriculture majors. Students are able to get hands-on experience in a variety of agricultural tasks, from vaccinating livestock to harvesting crops to milking cows, as Jayne Judd does in this 1979 photograph.

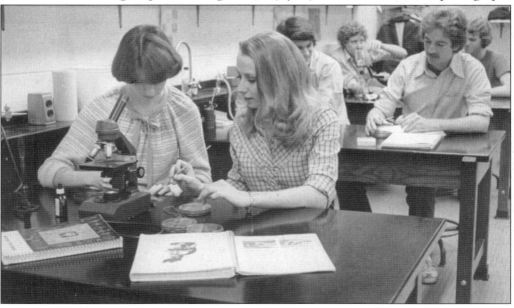

Microbiology students are checking the cultures they are growing in petri dishes in a 1979 class. Students can earn degrees in biology, biology teaching, environmental studies, and wildlife management. The three options available for biology majors are microbial, cellular, and molecular biology.

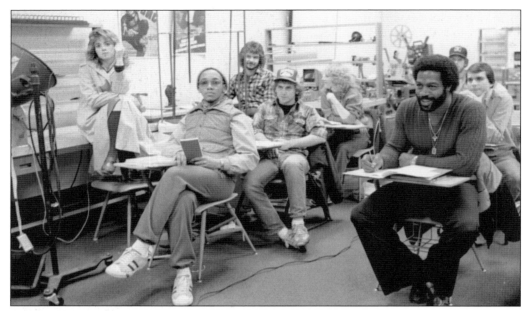

After playing professional football for seven years, Wally Chambers (front right) retired and returned to Eastern to earn a degree in broadcasting. His advice to aspiring athletes was to concentrate on education rather than sports. He is pictured here in a 1981 broadcasting class.

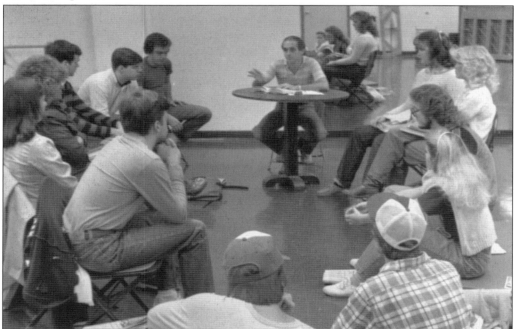

This 1982 drama class critiques the student performances. The theater department presented *All My Sons* as their fall performance this year and won first place in the Kentucky Theater Association Play Festival, making them the Kentucky representative to the American College Theater Festival.

These industrial arts students use a band saw to make toy trucks in 1982. The College of Applied Arts and Technology was recently merged with the College of Business to make the College of Business and Technology.

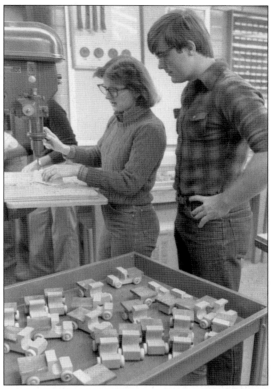

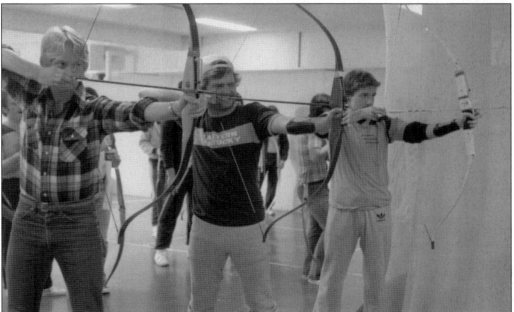

Archery was one of the many classes offered to these 1982 students to fulfill their physical education requirement. Other classes that have been taught over the years include fencing, badminton, tennis, kickboxing, yoga, weight lifting, and swimming.

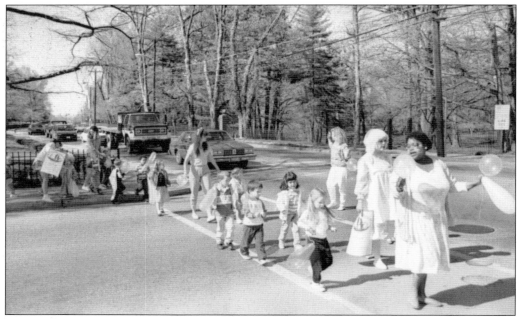

The Burrier Child Development Center opened during the 1975–1976 school year and served as a professional development laboratory for child development majors. The program was intended to complement the preschool and kindergarten programs at Model Laboratory School. These children are walking to the city park to release balloons in 1988.

Eastern's honor students are identified by the sash or mortarboard they wear at graduation. The maroon-and-white sash shown here in 1986 identifies those students having a grade point average above 3.5. Students wearing a maroon mortarboard are members of the honors program established in 1988. This program offers a challenging academic program and extracurricular activities that enhance regular classroom activities.

A 1984 ROTC cadet rappels from the front of the Begley Building. Buildings from left to right in the background are the Stateland Dairy Center, the Greg Adams Building, and the Carter Building.

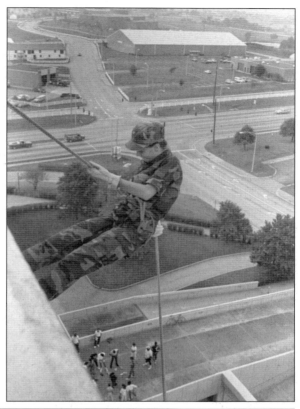

Prof. Ron Jones uses plant species in the Ravine to teach a 1998 botany class. Besides using species growing on campus, Eastern botany students also have access to a herbarium with over 55,000 specimens. Most specimens are from central and eastern Kentucky, but there is also a good representation from western Kentucky and the southeastern United States.

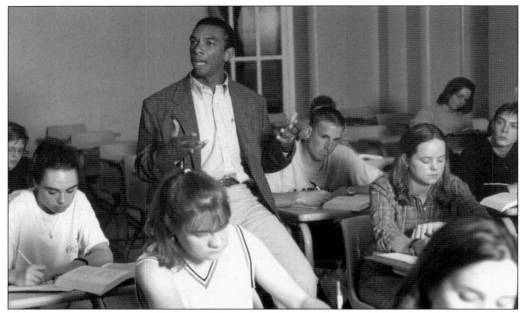

A degree program in sociology was first offered to students in 1966 when Eastern gained university status. This degree offers many students a good liberal arts background from which they can effectively move into many different career fields. Prof. Aaron Thompson is shown here teaching a sociology class *c.* 1998.

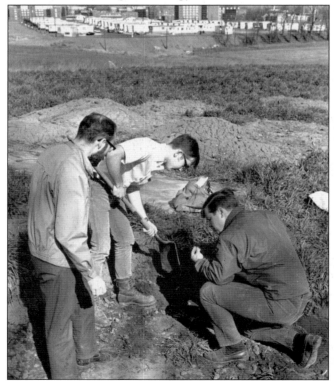

Prof. David Ward (left) and archaeology students excavate the remains of a Native American village just east of campus in 1969. About 2,500 pottery fragments and a dozen projectile points were found. A bachelor of arts degree in anthropology was first offered in 1966.

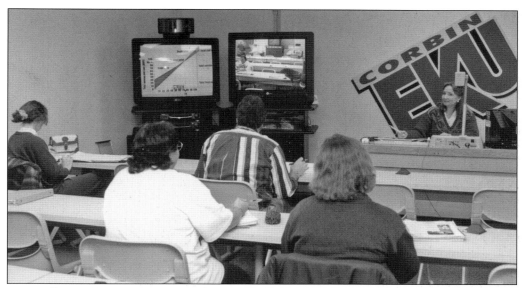

As enrollment on Eastern's extended campus centers in Corbin, Danville, and Manchester continued to expand, the university took steps to increase accessibility at these locations. One way this has been done is through the Kentucky Telelinking Network (KTLN), where the professor can lecture in Richmond and can interact with students at the centers. This 2000 photograph shows the Corbin KTLN classroom.

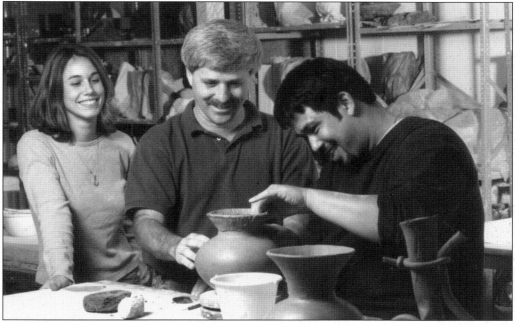

Eastern art students have a large ceramics studio equipped with electric potter's wheels, slab rollers, and clay extruders. Clay and glazes are stored and mixed mechanically in rooms immediately adjacent to the studio. Electric and alpine gas kilns are available, as well as a gas-fired salt kiln, a raku kiln, and additional space for experimental kiln building. Prof. Joe Molinaro (center) works with two ceramics students in the studio c. 2000.

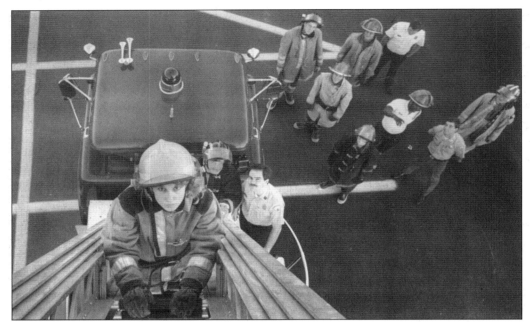

The Fire and Safety Engineering Technology Program was established in 1975 and is one of only a few programs in the country that offers undergraduate degrees in fire and safety. Areas of study include life safety; fire prevention, suppression, and investigation; fire service administration; fire protection principles; industrial loss prevention; safety program management; and occupational safety and health. This student participates in a training exercise *c.* 1977.

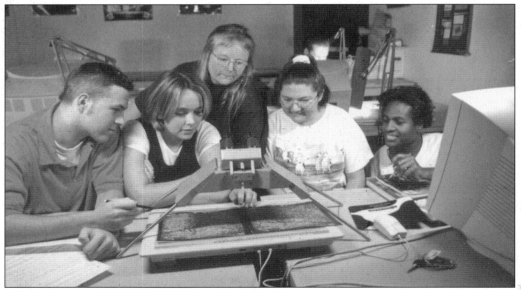

Students in the geography laboratory use a stereoscope to view a pair of aerial photographs taken seconds apart. When seen through the stereoscope, the landscape appears to be three-dimensional. Geography professor Alice Jones (center) instructs the students in this 2002 photograph.

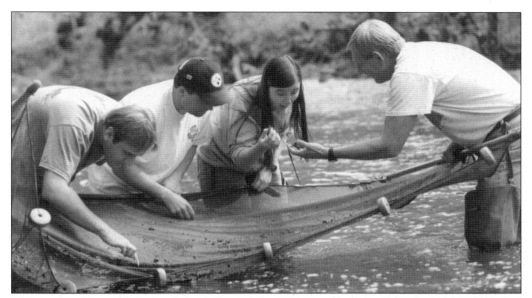

Biology graduate students, from left to right, Bill Stamm, John Johansen, and Kathrine Medlock work with biology professor Gunther Schuster (right) to seine fish and crayfish at Silver Creek outside Richmond in 2000. Hands-on experiences are an integral part of many Eastern courses.

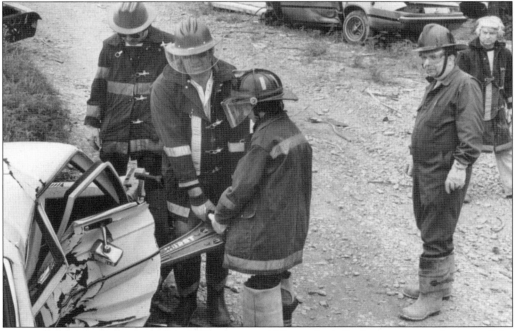

Fire prevention professor William Abney (second from the left) demonstrates the use of the Jaws of Life to extricate a passenger from a wrecked car c. 1980. Shortly after its creation in 1975, this department was the fastest growing in the college of law enforcement. That college has since been renamed the College of Justice and Safety to more accurately reflect the program offerings.

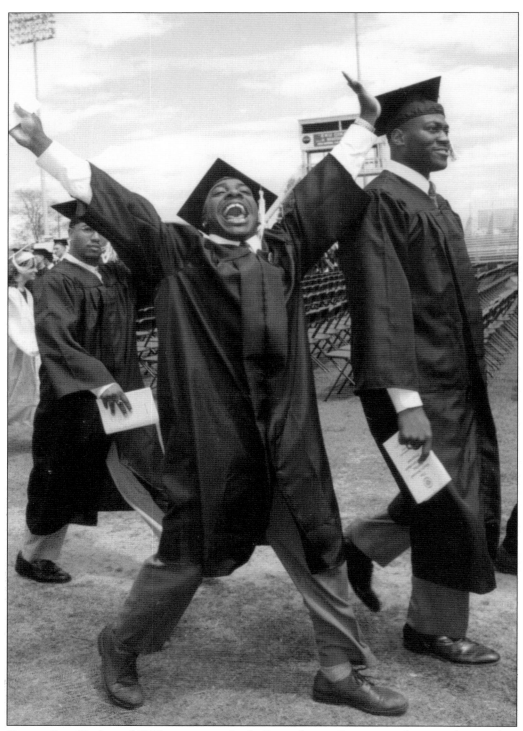

George Duvall, class of 1998, expresses the feelings of many Eastern graduates as he marches to get his diploma.

Three

STUDENT LIFE

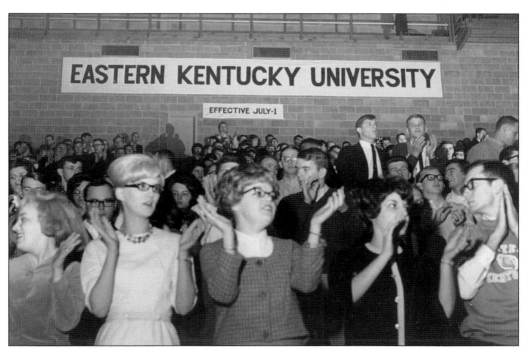

The students pictured here are applauding the 60th anniversary of Eastern's founding and the granting of university status. The school was founded on March 21, 1906, and on February 27, 1966, a bill was signed by Gov. Edward T. Breathitt granting university status to Eastern, Western, Murray, and Morehead State Colleges. This photograph was taken at Founder's Day ceremonies on March 21, 1966, and as the banner in the background indicates, the effective date of university status was July 1, 1966.

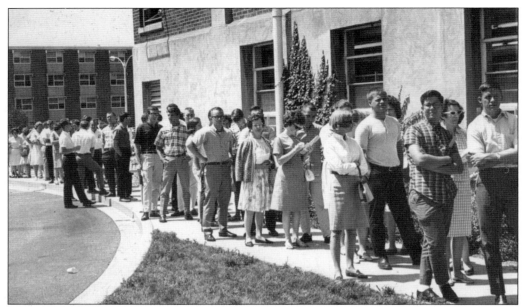

In a scene familiar to many college students, the caption in the *Milestone* for this photograph reads, "Registration lines were not endless, after all, they just looked that way." Although the image appears in the 1966 yearbook, it was most likely taken in the fall of 1965 when enrollment was nearing 7,000. The photograph was taken outside the Weaver Building (right), and Martin Hall is visible in the background.

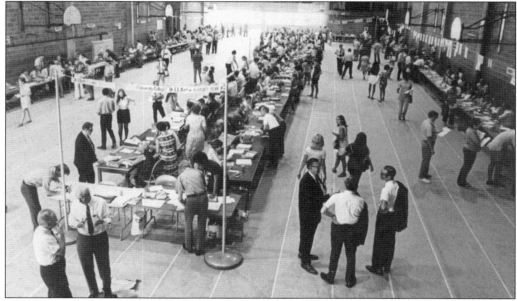

By the fall of 1968, with enrollment topping 8,000, registration was moved from the Weaver Building, and other sites near Weaver, to the auxiliary gymnasium in Alumni Coliseum. Students were instructed to "report to the ground level, northwest door (nearest the water tower)." As this 1971 image indicates, the space provided by the auxiliary gymnasium was better able to accommodate the growing enrollment, which was over 9,000.

One of the busiest times of the year on Eastern's campus is fall move-in day. With the help of family members and friends, students move back into the dormitories and get ready to start a new school year. These two images of that day, some 40 years apart, provide an interesting contrast. In the 1961 photograph at right, the student brings what can be packed in one automobile (including mom, dad, and little sister). In the 2004 photograph below, the student has a rental trailer and a moving dolly to haul furniture, bedding, and potted plants. In addition, the only one wearing high heels in 2004 is a cardboard cutout of Marilyn Monroe.

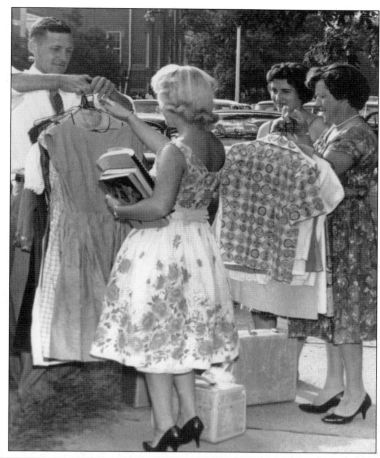

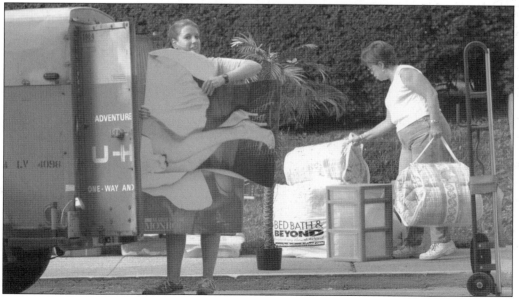

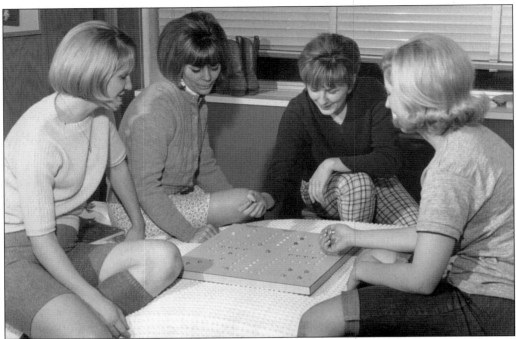

These two images present typical dormitory scenes from the late 1960s. Taken in late 1968 or early 1969, the photograph with the young men watching television appeared in the 1969 *Milestone*, in a section of the yearbook devoted to dormitory life. The introduction to the section reads, "There is nothing else quite like dormitory living. It is not necessarily a place for study or a place for lying around, but a medium through which a myriad of lasting experiences can be formed and enjoyed—without regard to the channel through which it happens to flow." The photograph of the young women playing Parcheesi was probably taken around the same time.

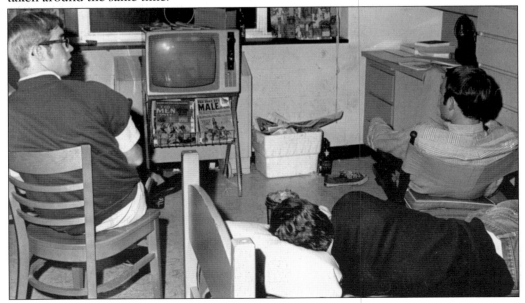

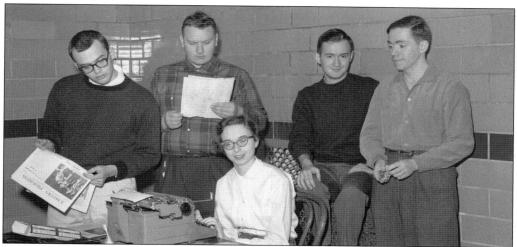

The student newspaper, the *Eastern Progress*, began publication in February 1922. It was preceded by two other student publications, the *Student* (1908–1915) and the *Talisman* (1915–1917). In 1922, when Eastern was authorized to expand to include a four-year standard college curriculum, Pres. Thomas J. Coates recognized that it was time to authorize a student newspaper. From 1922 to 1960, the *Eastern Progress* was published bimonthly, or every two weeks, and sometimes less often, but it became a weekly newspaper under the guidance of the newly created Public Affairs and Publicity Department in the fall of 1960. The students pictured in February 1960 would have been the last to work on the bimonthly publication. They are, from left to right, Larry Stanley (circulation manager), Emmett Moore, Carolyn Oakes, Charles Klonne (news editor), and Gerald Lunsford (sports editor).

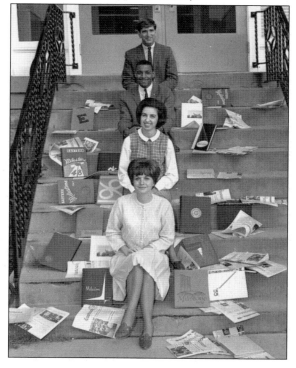

In this creative portrait from 1966, seated among past issues of the *Milestone* and the *Eastern Progress* are, from top to bottom, Gerald Maerz (*Eastern Progress* editor-in-chief), Norris Miles (*Eastern Progress* managing editor), Linda Ward, and Kem Manion (coeditors of the *Milestone*). These editors, who had a combined 13 years of service with Eastern publications, were awarded *Milestone* senior citations for outstanding student participation in publications. The *Milestone*, also started in 1922, was the senior annual that succeeded the *Bluemont* and the yearbooks published as issues of the *Eastern Kentucky Review*. The *Milestone* was published annually until 1999, with a brief halt during World War II.

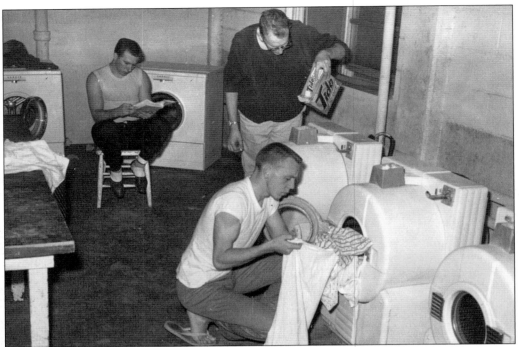

Although hairstyles, clothing, and machinery may change over the years (above image *c.* 1963 and below image *c.* 1971), one thing appears to stay the same—what brand of detergent young college men use.

Mary Evelyn and Jerry Brown pose inside the front door of their apartment in Brockton Housing. Built in 1960 specifically for married students, Brockton was advertised as "housing units [that] can be made into neat, comfortable homes." Both students were from Danville, Kentucky, and they were seniors at the time of this photograph. He was majoring in industrial arts, and she was majoring in English. The Browns posed for several photographs that appeared in the 1966 *Milestone*.

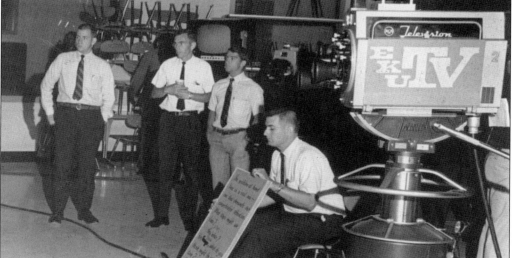

In 1966, Eastern established the Division of Instructional Services to make instructional media and technology available to faculty. The division was concentrated in four areas: instructional media, radio, television, and engineering services. In this *c.* 1968 photograph, chief engineer Gene Robbins (second from the left) can be seen with several unidentified students in the studio that was then located in Donovan Annex. At that time, EKU-TV was focused primarily on Model Laboratory School observation, providing live classroom feeds to education students in the Combs Building. They also videotaped courses, and this appears to be one such taping. The person in the foreground is holding a cue card with math-related questions.

As early as 1955, parking and congestion were issues on campus, and anyone who has attended Eastern in the last 50 years will attest to that. This image appears in the 1971 *Milestone* under the heading, "As Always, Traffic is a Problem." The caption reads, "The wide open spaces surrounding this 'bug' provide a contrast to the usual traffic situation on campus. The addition of several traffic lights did much to aid the problem during the year."

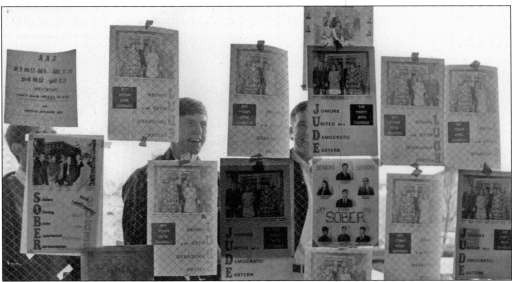

The students here are reading campaign flyers for class elections held on October 21, 1968. Students had organized 13 different parties, and 103 candidates from these parties, as well as several independents, were running for class offices. The parties used names such as the ones seen here: JUDE (Juniors United for a Democratic Eastern) and SOBER (Seniors Offering Better Experienced Representation). But there were also parties called HIPPIE (Honesty, Integrity, Personality, and Progress at Eastern), APPLE (American Progressive Party of Leaders at Eastern), and MOTHERS (Minds Organized to Hear Eastern's Responsible Sophomores). The SOBER, HIPPIE, MOTHERS, and APPLE parties were the big winners for senior, junior, sophomore, and freshman classes respectively.

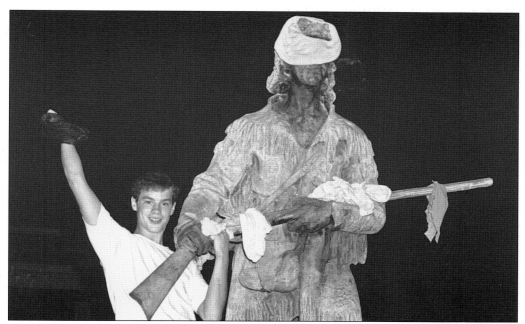

When this student posed with the Daniel Boone statue in October 1969, the *Eastern Progress* was reporting on a series of "panty raids." In this modified version of the old-fashioned panty raid, the young men involved did not actually enter any dormitory rooms. Instead the *Eastern Progress* reports that "some of the co-eds threw undergarments from room windows, though others dumped water to the ground." The director of safety and security was quoted as saying, "We had no real trouble from the boys. The nights were just hot and muggy, and everyone seemed to be a little bored."

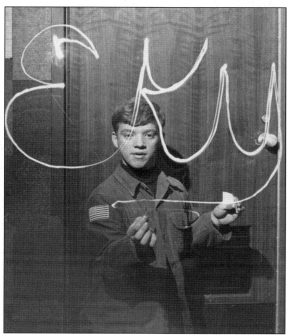

In this photograph, taken on March 13, 1970, Mike Hack uses a match to write "EKU" in a darkened room. In a similar image that appears in the March 26, 1970, issue of the *Eastern Progress*, he is seen drawing a man's head. Part of the caption for that photograph indicates that "when this shot was taken, the room was in total darkness. The light from the camera's flash produced the image . . . which Hack drew with the light from a match."

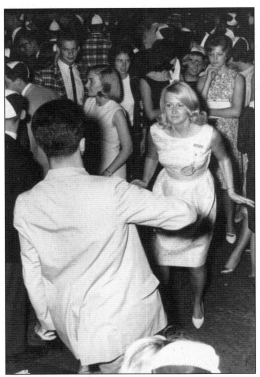

Students have fun at the all-freshman dance held at the conclusion of freshman week in September 1965. The young woman featured here is actually an upperclassman, as indicated by the badge she is wearing as a "Guide."

An unidentified band plays at the Snowball Dance on December 11, 1959. The Snowball Dance was a tradition for many years and was sponsored by KYMA (Kentucky Maroons Club). This year it was held in Walnut Hall of the Keen Johnson Building, and Kay Bowman was crowned Snowball Queen. The *Eastern Progress* described the decorations: "behind the orchestra in the form of a backdrop was Santa, his sleigh and reindeer in original colors. This was surrounded with cedar and blue snow." Tickets for the semiformal dance were $1.50, and flowers were "optional."

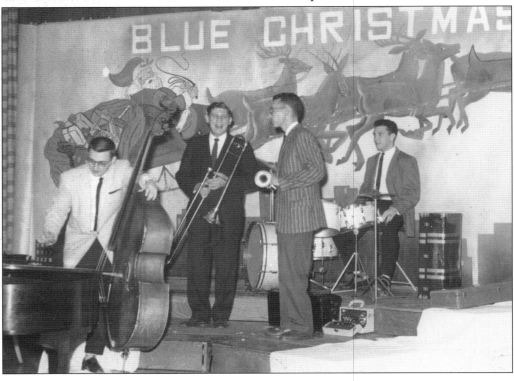

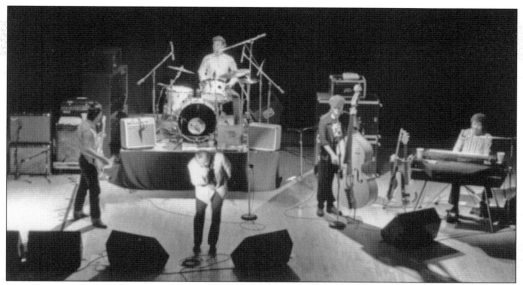

This photograph, taken in Brock Auditorium on the night of September 13, 1986, shows the Fabulous Thunderbirds playing before a crowd of 900 students. Beginning in the early 1970s, the campus was host to musical acts ranging from Seals and Crofts, Harry Chapin, the Temptations, Arlo Guthrie, and Billy Preston to the Glenn Miller Orchestra and Buddy Rich.

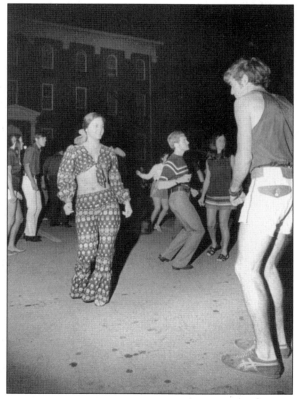

Outdoor dances such as this one, held in the parking lot that was located between Crabbe Library and the Combs Building, were a fall staple for many years. This photograph, taken in the early 1970s, contrasts nicely with the image on the preceding page taken in 1965. The style of dress is much more casual, and hairstyles have changed.

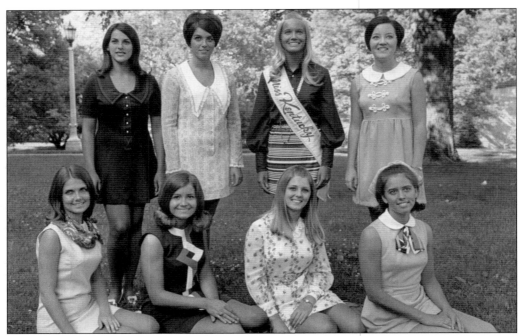

Several Miss Kentucky winners have been students at Eastern. This May 1970 photograph shows eight Eastern students, who will participate in the 1970 Miss Kentucky Pageant in Louisville, including the reigning Miss Kentucky. They are from left to right (first row) Julia Williams, Brenda Clark, Beverly Disney, and Janice Haviland; (second row) Janice Jones, Marty Peyton, Louisa Flook, and Bonnie Crisp.

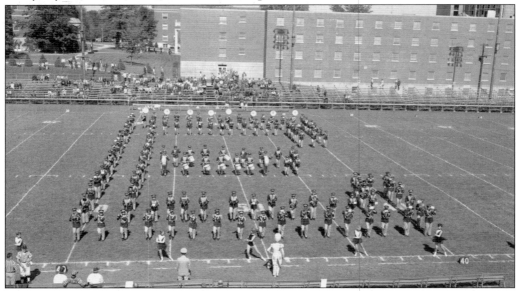

In this image, the Marching Maroons can be seen in the classic "E" formation that the university marching band has used for decades. This was taken at halftime of the Eastern vs. Marshall game on September 25, 1965, (Eastern lost that game 28-12). Buildings pictured here include the Keen Johnson Building (back left) and Case Hall (right).

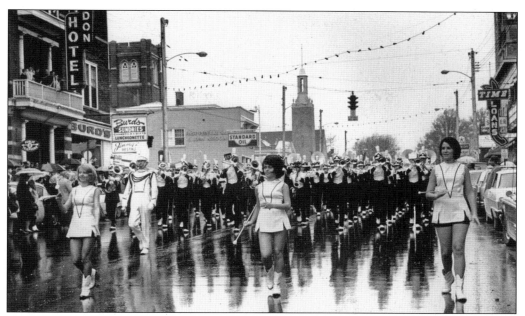

The homecoming parade on Main Street in downtown Richmond on November 5, 1966, was a wet one, but according to the *Eastern Progress*, "there was nothing damp about the spirit of the students who turned out in great numbers to attend homecoming festivities." Of the businesses pictured here, only the Glyndon Hotel (left) remains. They have all left downtown or no longer exist.

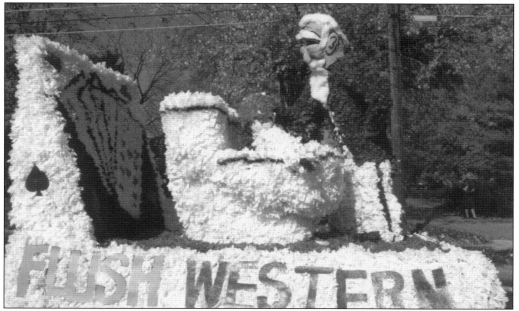

The ongoing rivalry between Eastern Kentucky University and Western Kentucky University stretches back to the very early days when both were normal schools. The floats for homecoming parades have been very creative. This one of "Flush Western" is a good example of that creativity in the 1970s.

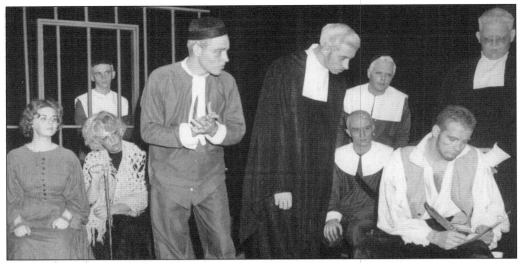

In this November 1962 photograph of a Little Theatre production of *The Crucible* is one of the lead actors in the play, Harvey Lee Yeary (seated at right). Most people recognize him as Lee Majors. Majors—star of several television series including *The Big Valley* (1965–1969), *The Six Million Dollar Man* (1973–1978), and *The Fall Guy* (1981–1986)—came to Eastern on a football scholarship, but when an injury cut his playing days short, he turned his energies to acting.

The University Ensemble, pictured here in a December 1971 performance, was organized on the Eastern campus under the leadership of Paul Eric Abercrombie. He formed the group in 1967 as a choral institution, whose mission was "bringing to light the timely and universally pertinent message of the Christian faith." They were together for several years and produced at least two albums, *In the Beginning* and *We've Come This Far By Faith*.

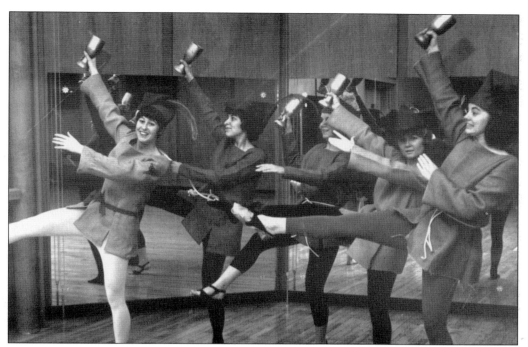

In this December 1965 photograph, members of the Drum and Sandal Club rehearse a performance depicting the ancient Yuletide custom of wassailing (drinking to your good health). This was a rehearsal for their annual Christmas show, which this year was entitled "Christmas Kaleidoscope." The Christmas show that year deviated from the traditional aspects of interpretive dance, demonstrating a more modern approach.

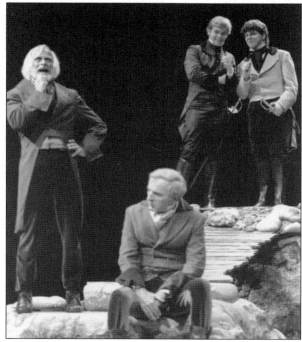

In October 1984, the Theatre 100 class presented the first Shakespearean play to be performed on the campus in 10 years. The production of *The Tempest* featured students and faculty. In this scene, Sebastian (left background) and Antonio (right background) plot against Alonso (right foreground), who is being consoled by Gonzalo (left foreground). The actors are, respectively, Dwight Craft, Tom Highly, Robert Burkhart (chair of the English Department), and Paul Winther (anthropology professor).

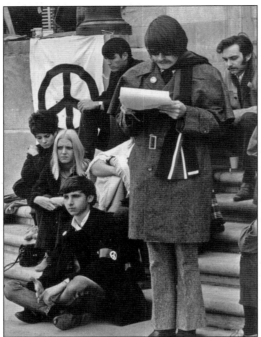

The campus unrest that was widespread in the United States during the 1960s did not entirely pass by Eastern. Although the *Eastern Progress* reported in March 1969 that the "first organized demonstration of protest in Eastern's history" had taken place that month, it was not about the Vietnam War but about the censure by the board of regents of student council president Steve Wilborn. This image is the next recorded demonstration when, in October 1969, some 800 students, including those pictured here on the steps of the Keen Johnson Building, took part in the nationwide moratorium for the American dead in Vietnam.

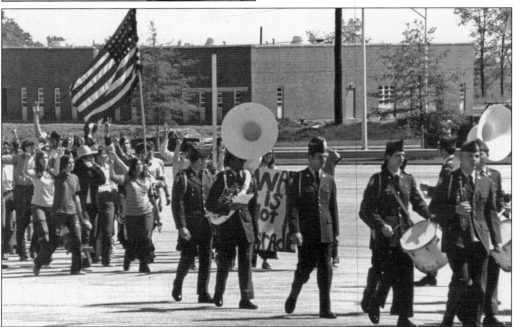

On May 7, 1970, a group of 100–150 students protested the Vietnam War at the annual president's and dean's review of the ROTC. The protestors carried an American flag, a wooden cross, and a large sign reading, "War is not a Parade," as they followed the ROTC companies out of the Alumni Coliseum parking lot. The demonstration was described as generally peaceful and included a lowering of the Coliseum flags to half staff "in memory of and respect for" the four students who had been slain on May 4, 1970, at Kent State University.

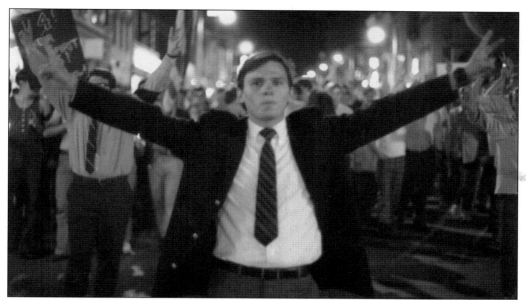

On the evening of May 7, 1970, student association president Jim Pellegrinon (with arms outstretched) led about 800 students through campus in protest of the Vietnam War. As the march wound through campus to downtown Richmond, where this photograph was taken, it grew to about 1,200 students. Following the march, many of the students held a "sleep-in" in the Ravine while they waited to hear from university president Robert R. Martin. He spoke to a capacity crowd the next day in Brock Auditorium, where the students presented a list of questions they had drawn up the night before.

In this photograph, two students protest the mandatory military science courses for freshmen and sophomores, the use of campus police to search dormitory rooms, frequent bed checks, and other administration policies. By the late 1960s, when this photograph was probably taken, mandatory military science was on the way out. In June 1969, the board of regents approved a change in policy, so that by the time of the 1970–1971 school year, students would be offered "options" in lieu of military science.

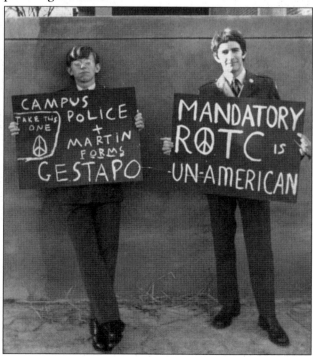

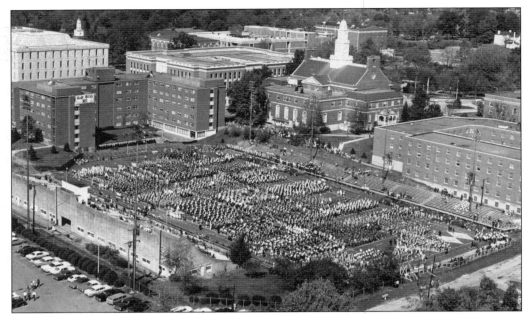

In this photograph from October 14, 1967, some 5,000 students from 71 Kentucky high schools marched onto the field at Hanger Stadium to the strains of *Finlandia, Born Free*, and *America the Beautiful*. Beginning in 1961 and continuing through the 1970s, Eastern hosted high school bands for a halftime show at football games. Those games were billed as High School Band Day.

John Davenport gets a pat on the head from Pres. Robert R. Martin during halftime at the Tennessee Tech basketball game on February 26, 1972. The occasion was the presentation of the first-place state trophy for the Eels, the swim team, who had actually won their 10th straight Kentucky Intercollegiate Swimming and Diving Championship earlier the same day. Davenport, in addition to being on the swim team, was president of the "E" Club, an organization for athletes who have lettered in intercollegiate sports.

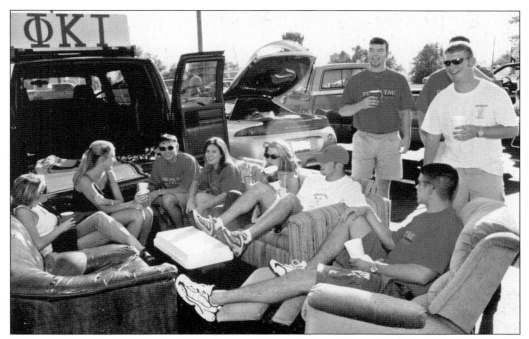

Tailgating comes of age in the late 1990s. In this *c.* 1998 photograph, members of Phi Kappa Tau demonstrate that simply cooking out in a parking lot is not necessary when you can set up easy chairs and sofas and let a cooler serve as the coffee table.

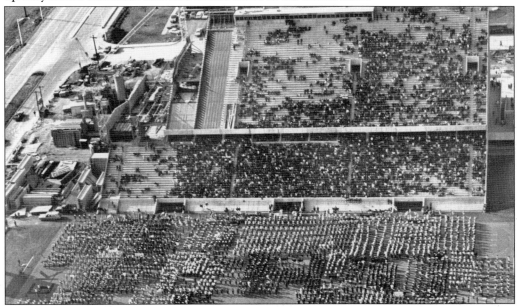

Band Day, Saturday, November 13, 1969, featured more than 60 high school bands on the new Hanger Field with the almost completed Begley Building, which would serve as the new football stadium. In 1990, the stadium was named for longtime football coach Roy Kidd. This particular High School Band Day halftime show occurred during a game with Tennessee Tech that Eastern won 17-7.

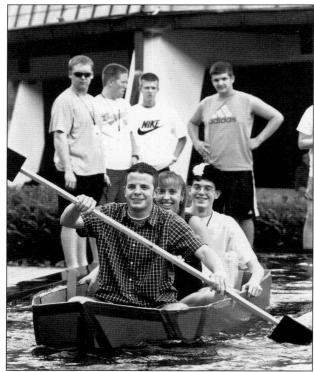

The fountain in Powell Plaza has attracted students for a variety of reasons since it was built in 1972 to complement the Chapel of Meditation. During the summer of 2002, it attracted students participating in the Governor's Scholars Program for a cardboard boat regatta. These gifted high school juniors, from across Kentucky, are invited each summer to visit a university campus to participate in a six-week program, designed to give them "a goal, a standard, and a high challenge."

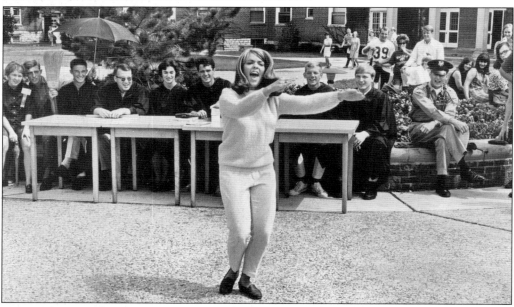

In the fall of 1966, Cathy Hellen was hauled into "rat court" for not wearing her freshman beanie cap. Her sentence was an impromptu song and dance routine. According to a September 1965 article in the *Eastern Progress*, rat court was not for the purpose of harassment "but rather to impose penance on the freshmen who neglected to orient themselves to the contents of the student handbook." Rat court had no connection to student council.

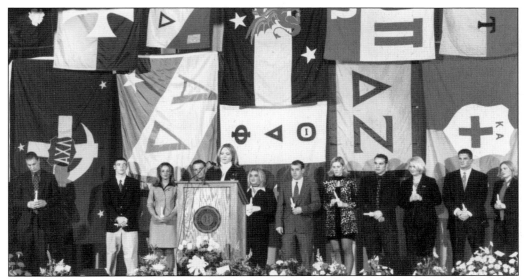

This photograph was taken during Eastern's Greek weekend in 1998. The annual Greek weekend is the only time all the Greek organizations on campus come together for competitions to show spirit and celebrate scholastic and philanthropic achievements. Awards are given to individuals and chapters as a whole and usually include awards for best Greek man, best Greek woman, and highest chapter grade point average.

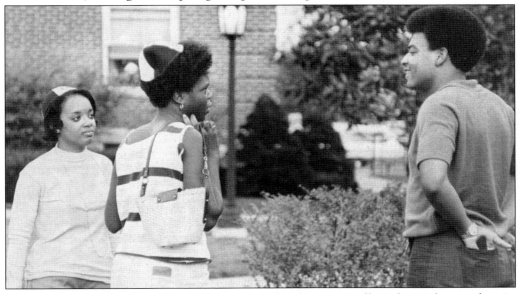

In this fall 1970 image, two students wearing "beanie caps" talk with another student in front of the Keen Johnson Building. The caption for this photograph in the 1971 *Milestone* reads, "Two beanied freshmen come under the approving eye of an upperclassman on the student plaza." The wearing of beanies by freshmen seems to have been an on-again, off-again tradition that apparently died off sometime in the 1950s, was revived in 1961, and then died out again in 1973. The October 20, 1961, *Eastern Progress* editorialized that the revival of the caps was "an attempt to instill within the news students a real loyalty and school spirit, which will last until their graduation day and thereafter as an alumnus."

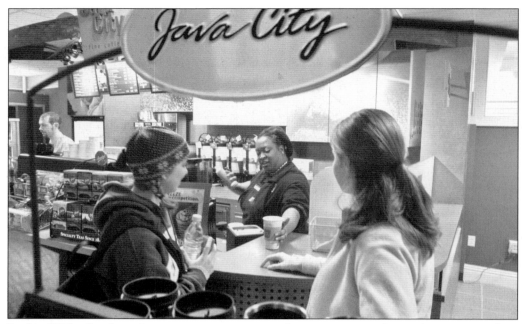

In the 1990s, food services on campuses across the country were becoming privatized, as universities were leasing their facilities to companies, such as Aramark and Marriot. With these changes, students could choose name-brand fast foods, such as Burger King and Chick-fil-A, in the Powell Building food court and at other food service areas across campus. This photograph shows the Java City Library Café in 2004, shortly after its opening.

In this 1966 photograph, two students stop to pet a dog. The caption for this image in the 1967 *Milestone* says that "the Ravine provides a good shortcut to and from classes, but a show of friendliness is always a welcome diversion." In those days, the bulk of the classrooms were still in close proximity to the Ravine.

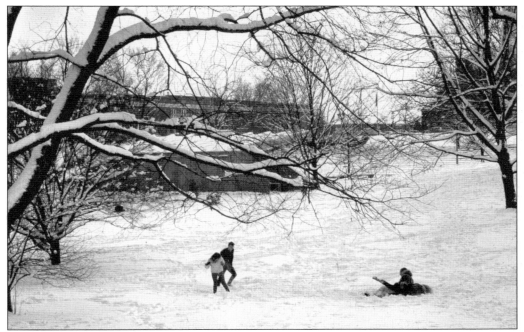

In addition to providing a shortcut to and from classes, the Ravine has always provided a place to soak up the elements, wander at your leisure, and study. Occasionally, in the winter, it is the scene of fun in the snow, as depicted in this winter 1965–1966 photograph. Whenever there is a good snowfall, the Ravine is sure to attract students from across the campus.

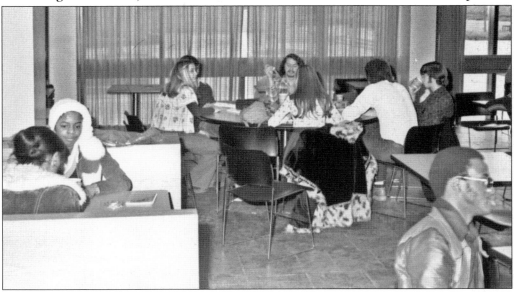

When it was opened in 1972, food services moved from the cafeteria in the Keen Johnson Building to the upper level of the Powell Building. In the old building, there had been the Grille in addition to the cafeteria. In the new setting, as demonstrated in this February 1975 photograph, students now gathered in a larger space referred to as simply "the grill" on the lower level of the Powell Building where other breakfast and lunch options were available.

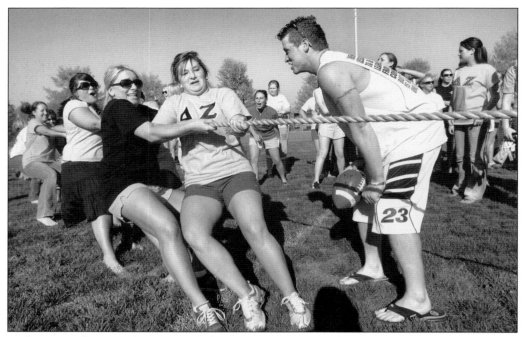

In this 2005 photograph, members of Delta Zeta sorority compete in a tug-of-war contest with an unseen opponent during competitions sponsored by the Sigma Chi fraternity. However, according to the spring 2005 issue of the *Leader's Lantern*, the EKU Panhellenic newsletter, the Kappa Delta sorority took first place in the Sigma Chi Derby Days.

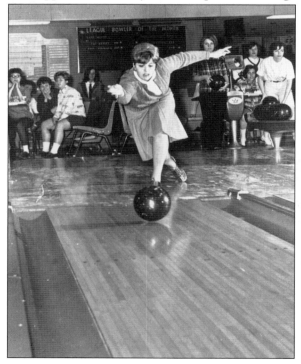

Throughout the 1960s, women's sports continued to be intramural rather than intercollegiate. The caption in the 1966 *Milestone* for this photograph reads, "An intramural bowler demonstrates the proper techniques of approach and release." Some women's intramural teams participated in unsanctioned intercollegiate competition. For instance, the 1966 women's field hockey team competed against Centre College, Transylvania University, University of Kentucky, and Berea College.

In November 2000, the College of Justice and Safety and the College of Education cohosted the America's Promise Kentucky Summit. Retired general Colin Powell, later secretary of state, founded America's Promise—the Alliance for Youth in 1997 as an effort to mobilize Americans to build the character and competence of the nation's youth. Eastern became the first Kentucky University of Promise in 1999. At the time of this summit, Gov. Paul E. Patton signed the America's Promise Governor's Partnership. Powell (center) is flanked in this photograph from that signing by Gov. Paul E. Patton (right) and Pres. Robert Kustra (left).

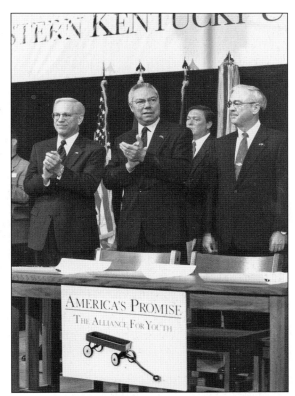

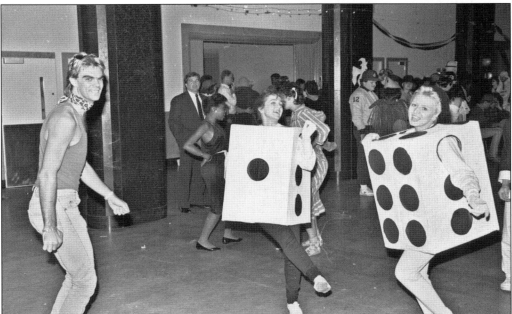

Halloween is always a good excuse for a party! This October 29, 1986, party, held in the Keen Johnson Building ballroom, featured music by the Outrageous Music Machine (presumably a local DJ) and the opportunity to dance with a pair of dice.

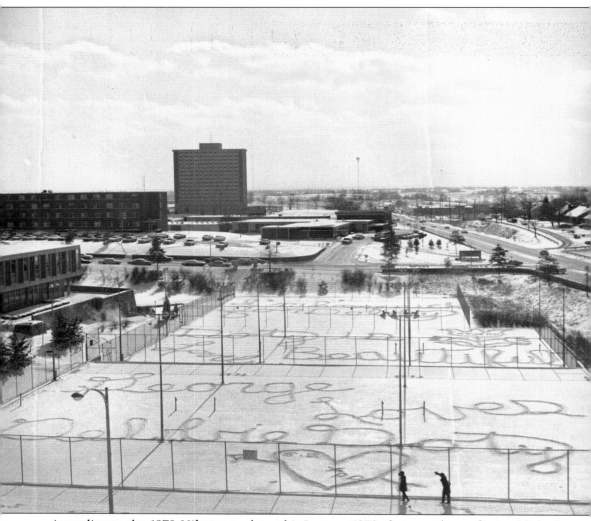

According to the 1970 *Milestone*, where this January 1970 photograph was first published, "A bitter winter confronted us with paradoxical situations. Snow-covered tennis courts permitted young love to be proclaimed to all, but when sub-zero weather and a power failure combined to stop heat in the dormitories, and we became tired of trudging to class through those record snow falls, we were ready for spring."

Four

ATHLETICS

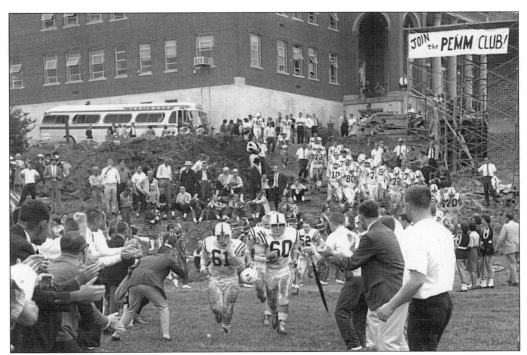

In this fall 1962 photograph, cocaptains Tom Sharp (61) and Ken Goodhew (60) lead the way onto the field at Hanger Stadium for a home game. In the background is the Weaver Gymnasium and, to the right, the scaffolding on the not-yet-completed McGregor Hall, with a banner for the PEMM Club. PEMM was the Physical Education Majors and Minors Club, which traditionally decorated the Weaver Gymnasium for homecoming; however, this year, due to ongoing construction projects, they decorated the entrance to Hanger Stadium instead.

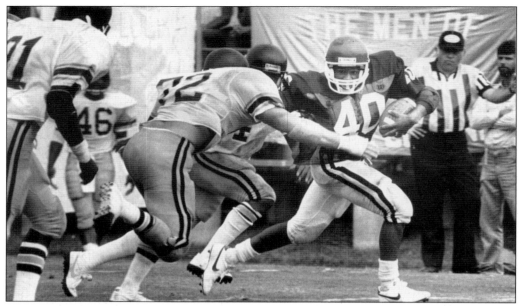

Vincent Scott Jr. is seen here carrying the ball at the homecoming game on October 13, 1984. Eastern beat the University of Central Florida 37-14 in a season that saw them take their fourth consecutive Ohio Valley Conference (OVC) Championship. Scott, a freshman tailback, only played in three games that year but got 109 of 139 total season yards during this game.

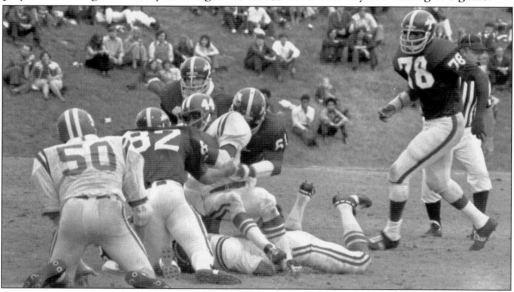

In this October 23, 1971, photograph, Wally Chambers (78) comes in from the right toward the end of a play involving James Croudup (51) and Mark Shireman (82). This homecoming game against Western Kentucky, which Eastern lost 16-7, came just one week after a 0-0 tie with nationally ranked Eastern Michigan. Wally Chambers went on to a career in the National Football League (NFL) with the Chicago Bears and the Tampa Bay Buccaneers. In 1973, his first year as a defensive end for the Bears, he was named the NFL's Defensive Rookie of the Year and played in the defensive line of the NFC Pro Bowl team.

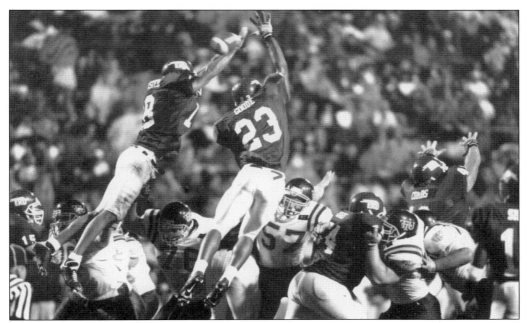

Despite this effort by Alex Bannister (18) and Redmond Goode (23), in the air, at apparently blocking a kick, Eastern lost this home opener on September 23, 2000, to Tennessee Tech. The EKU players seen in action here are, from left to right, Nick Sullivan (15), Bannister, Goode, Marcus Adams (54), Shorty Combs (48), and Eric Sims (19). Bannister was a fifth-round draft for the Seattle Seahawks in the 2001 NFL draft.

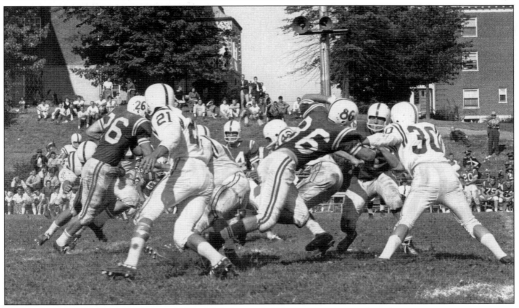

On October 28, 1961, Eastern met Western Kentucky for another homecoming game at Hanger Stadium. In the background are the Keen Johnson Building (left) and Burnam Hall (right). The only Eastern players clearly visible on this play are Larry McKenzie (21) and Jerry Lansdale (30). Unfortunately Eastern lost this game by a score of 16-15.

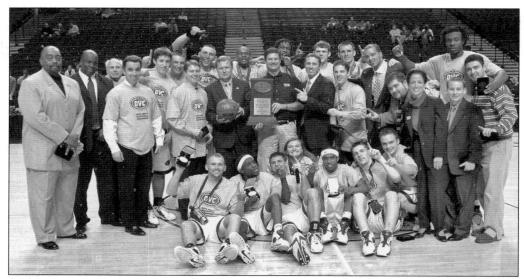

On March 5, 2005, the men's basketball team took the OVC Tournament Championship and won their first bid to the NCAA Men's Basketball Tournament since 1975. The head coach, Travis Ford (seventh from the left) and Pres. Joanne Glasser (fourth from the right) are pictured here surrounded by the team. The OVC trophy can be seen in the middle.

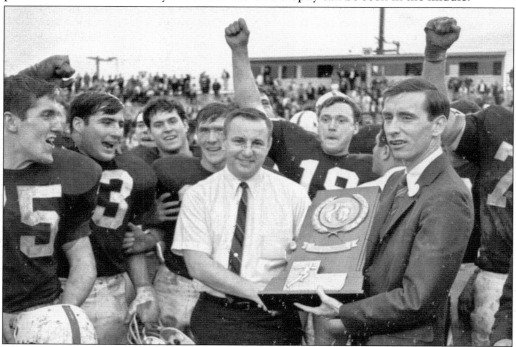

In 1967, head football coach Roy Kidd won his first Ohio Valley Conference Championship. The team went on to the Grantland Rice Bowl and a win over Ball State by a score of 27-13. This December 9, 1967, photograph shows the young head coach holding the trophy for that bowl game. The Grantland Rice Bowl was the NCAA Mideast Regional championship game played in Murfreesboro, Tennessee.

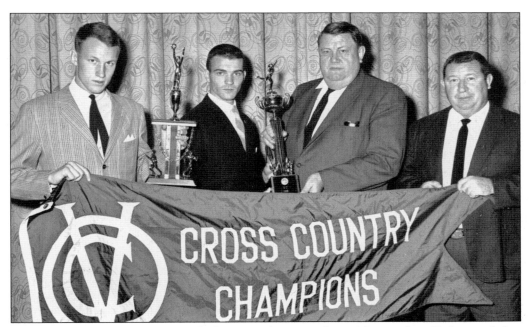

The 1965 cross-country team took the OVC Championship with a perfect 10-0 record that included wins over much larger universities such as Kentucky, Illinois, Iowa, and Indiana. The four men holding the banner and trophies are, from left to right, team members Kenth Andersson and Larry Whalen, Pres. Robert R. Martin, and coach Connan Smith. Smith was named OVC Cross-Country Coach of the Year.

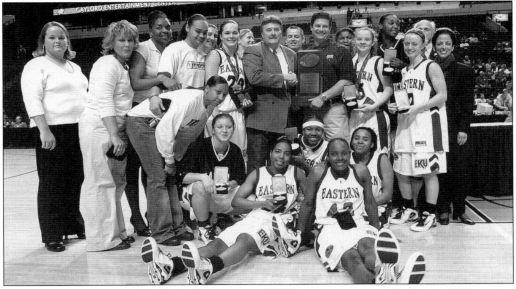

The 2004–2005 women's basketball team went 23-7 for the season and 15-1 in the OVC to take first place in the conference, as well as the OVC Tournament. The win in the tournament gave them an automatic bid to the NCAA Women's Basketball Tournament. In this photograph, the OVC trophy is being presented to head coach Larry Joe Inman (in the middle in coat and tie), and Pres. Joanne Glasser is at the far right.

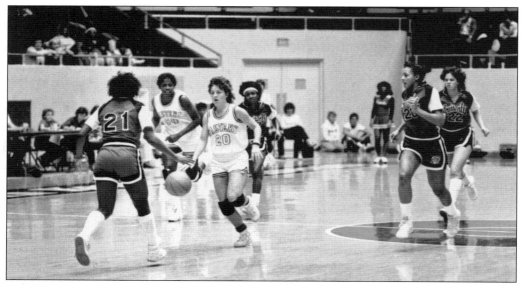

Lisa Goodin (20) heads for the basket in this February 1, 1984, game against Louisville. She is followed closely by several Louisville players and teammate Tina Cottle. The Lady Colonels won this game 69-55, and Cottle finished with a game high 24 points and 17 assists. Goodin contributed 14 points to this game and finished the year with a four-year total of 1,920 points, making her the all-time leading scorer in Eastern's women's basketball program as of 2006. She is also a member of the EKU Athletics Hall of Fame.

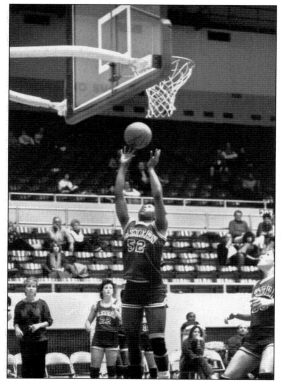

In this January 27, 1985, game against Austin Peay, Angela Fletcher (52) is about to score two points in a losing effort. Teammates Margy Shelton (22) and Tina Reece (far right) are also visible in this photograph. The Lady Colonels finished a disappointing season with an 8-17 record (1-13 in the OVC), and head coach Dianne Murphy resigned in June 1986 after seven seasons at Eastern.

The 1977 *Milestone* caption for this image reads, "Gayle Freshwater and Emma Salisbury appear to be all arms and hands as their UT opponent attempts a shot." That indicates that this is the February 12, 1977, game against the University of Tennessee, which was ranked 12th in the nation. Freshwater is at the left and Salisbury is wearing number 15. In the background, Jane Long, number 25, can be seen coming to assist.

This is Louista Pierre (10) in action against Arizona State in the 2005 NCAA Tournament played in Fresno, California, on March 19, 2005. The Colonels were the No. 12 seed and lost to No. 5 seed Arizona State, 87-65, in the first round. The loss snapped a school-record 15-game winning streak in a season where the team finished 23-8 overall.

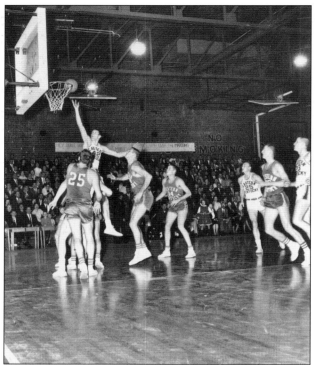

This was a home game against longtime rival Western Kentucky, played in Weaver Gymnasium on February 18, 1959. Eastern players visible are, from left to right, Bernie Kotula (42), Ray Gardner (25), and Rupert Stephens (23). This game, which they won 72-70, gave them a 9-2 record in the OVC. They ended the season 16-6 overall and 10-2 in the OVC to win the conference title.

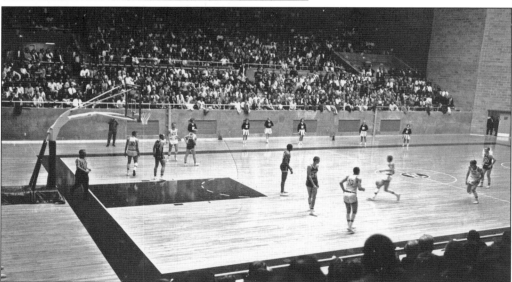

On December 4, 1963, Eastern played Louisville in the dedication game for the newly constructed Alumni Coliseum. Before a packed house of 6,500, and with governor-elect Edward T. Breathitt in attendance, the Maroons upset the favored Louisville Cardinals by a score of 78-65. Eastern players visible on the court are, from left to right, Dennis Bradley (30), Lee Lemos (20), Eddie Bodkin (10), unidentified, and Bob Tolan (52). The unidentified Eastern player is probably Herman Smith, who was a regular starter and was mentioned in the media guide that year as someone who "will share play-making responsibilities with Lemos."

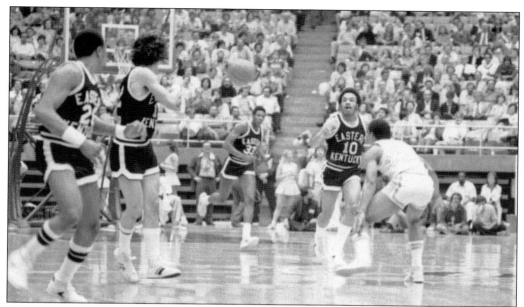

After winning the OVC Men's Basketball Championship in 1979, the Colonels seemed ready to take on Tennessee in the NCAA Midwest Regional Tournament. In this photograph, taken at the NCAA Tournament on March 9, 1979, Kenny Elliot (10) passes the ball to Dave Tierney (back to the camera), while Vic Merchant (22) and Chris Williams (33) provide support. It was a disappointing loss for the team, but head coach Ed Byhre was named OVC Basketball Coach of the Year for 1978–1979.

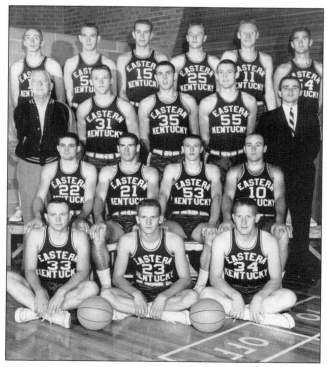

The 1960–1961 basketball season was a tough one in the Ohio Valley Conference (OVC). Coach Paul McBrayer (third row, far left), in his 15th year as head coach, had to settle for a three-way tie with Western Kentucky and Morehead to be Tri-Champions in the OVC. The team ended the season playing three games in a row against Morehead. They lost the first game, won the second (for the tie), and lost the third game to end their chances for a berth in the NCAA Midwest Regional Tournament.

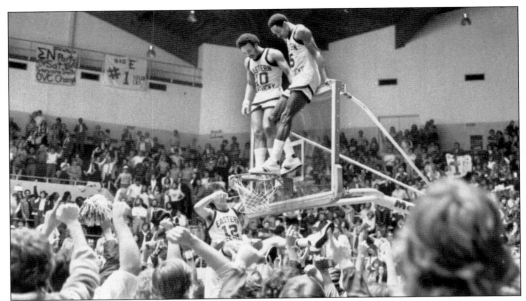

At the end of the March 3, 1979, OVC championship game against Western Kentucky, the team gets involved in taking down the net. Pictured here are Kenny Elliot (10) and James "Turk" Tillman (5) perched atop the basket as Dave Tierney (12) cuts down the net. On the basis of this win, the team advanced to the NCAA Midwest Regional Tournament but lost in the first round to the University of Tennessee Volunteers.

The cheerleaders in this fall 1961 photograph are getting the home crowd ready for the players who will emerge from the locker rooms located in the Weaver Gymnasium (back left). To the right in the background are the third-floor windows and roof of Keith Hall.

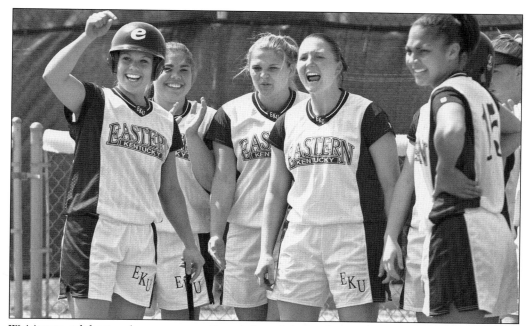

Waiting to celebrate a home run are, from left to right, Bethany Herrington, Jessica Soto, Kim Kelly, Amber Berthoud, and Elise Burch. This *c.* 2003 photograph was taken at the Gertrude Hood Women's Athletic Field. The field is named to honor Gertrude Hood, a pioneer in the physical education area for women. She served Eastern for 45 years (1928–1972) and was instrumental in the development of women's athletics at both the intramural and intercollegiate levels.

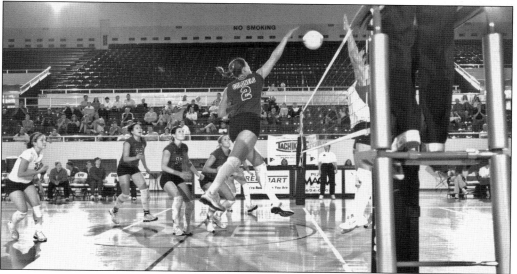

In this October 9, 2004, home game against Samford, the women's volleyball team is seen in action. From left to right are Brittany Nobilio (3), Jessica Sabath (22), Leslie Aldridge (12), Kelly Jennings (10), and Kasha Brooks (2) leaping toward the ball. The 2004 team had the best year of any team in the seven-year history of OVC play when they were 27-5 overall and 15-1 in the OVC. They were OVC Cochampions and OVC Tournament Champions.

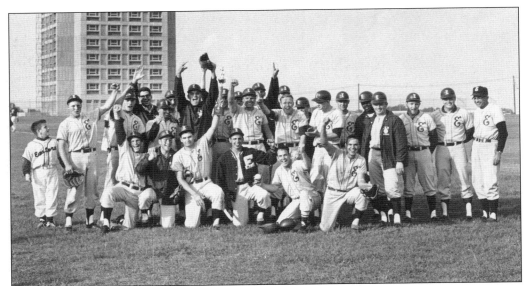

On May 19, 1967, the Eastern baseball team won a record 10th OVC Championship in 20 years of OVC play. In this photograph, the team is celebrating not only that win but their clinching the Eastern Division Championship three days earlier on May 16. Head coach Charles "Turkey" Hughes was also named OVC Baseball Coach of the Year for the second year in a row. The nearly completed Commonwealth Hall, with scaffolding still attached, is clearly visible in the background.

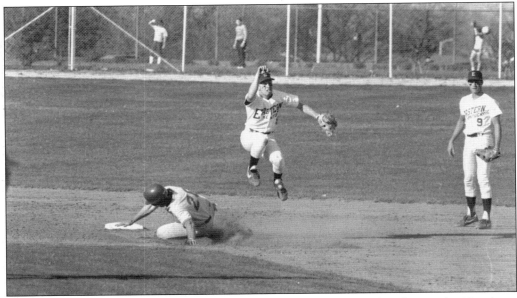

In this April 1986 image, the Colonels are in action against Morehead. As Mike Morrissey looks on, an unidentified Eastern player appears to be going for a double play. The team won the OVC Baseball Championship that year as well as the OVC Tournament. That win propelled them into the NCAA regionals for the third year in a row.

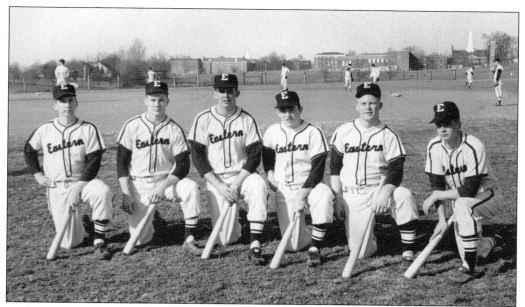

In the 1950s and early 1960s, the baseball team played on a field that was located on what is now Keene Hall. Part of the team poses in this 1959 photograph, with the field in the background. They are, from left to right, Charles Combs, Fred MacFarland, Larry Wayne Wood, Paul Shannon Johnson, John Edward Draud, and Bobby Mills.

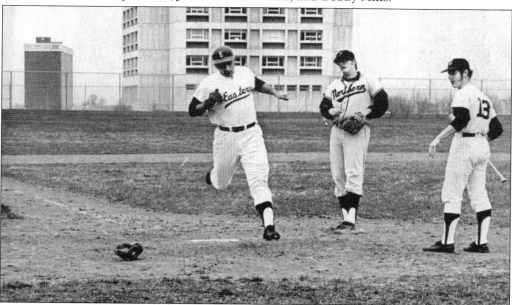

Eastern opened the 1971 season on March 22 with a double-header against Ohio Northern. A disgusted Ohio Northern pitcher covers home plate as Tim Jones scores in the first game on a wild pitch. The Colonels swept the double-header and won again the next day against Louisville, to give them a three-game opening win streak. Commonwealth Hall (right) is in the immediate background, and Telford Hall (left), constructed in 1969, is visible in the far background.

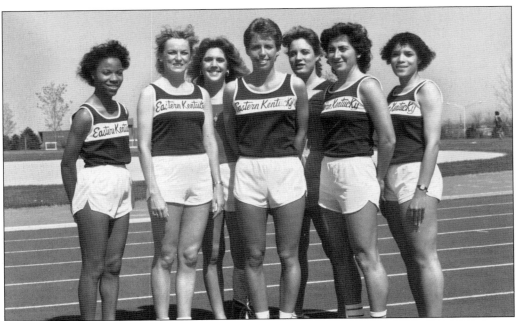

In the fall of 1982, the women's cross-country team took their first OVC Women's Cross Country Championship. This would be the first of 18 championships in a row for the women's cross-country team. Seven of the 10 team members are pictured here on the Tom C. Samuels Track. From left to right, they are Paula Garrett, Karen Haden, Lisa Renner, Eve Combs, Linda Davis, Maria Pazarentzos, and Pam Edmonds.

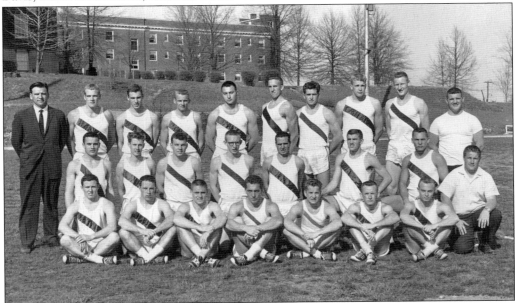

The 1960 "thin-clads" did not have a particularly successful season, finishing fifth in the OVC. The track team, pictured on the old Hanger Stadium with Burnam Hall in the background, did have one member who would go on to great success in television. Harvey Lee Yeary, third row, second from the left, is better known as Lee Majors.

Despite an impressive 10-1 season record, the 1962 track and field team finished second in the OVC Championship meet. Among the team members were these five men, who decided crucial meets this year. They are, from left to right, Ron Mendell (javelin), Bob Nightwine (discus), Larry Maddox (shot put), Richard Carr (discus), and Herb Conley (javelin).

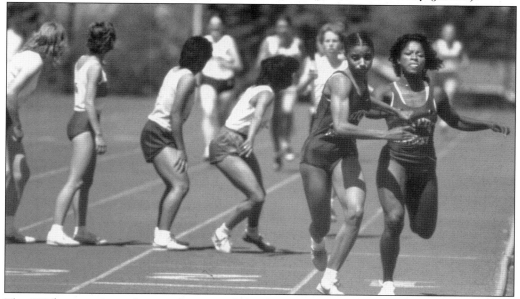

The 1986 women's track team dominated the OVC, winning all of their meets. Seen here at the 1986 Becky Boone Relays is Jackie Humphrey (far right) handing off the baton to Gracie Brown in the 4-by-400 meter relay. Humphrey would go on to win the 100-meter hurdles at the United States Olympic Team Trials in 1988 and compete in the Seoul Summer Olympics that same year. In 1986, she set an OVC record in the 100-meter hurdles that still stood as of 2006.

The four young men featured here were described as key members of the rifle team that took the second-place trophy at the Kentucky Fall Invitational Meet sponsored by the National Rifle Association (NRA). They are, from left to right, Ralph Klaber, Bill Rigby, Dale Jackson, and David Spratt. The meet was held in Murray, Kentucky, October 15–17, 1965.

After finishing the season at 11-3 and taking second place in both the state tournament and the Kentucky Women's Intercollegiate Conference regional meet, the 1974 women's gymnastics team finished a disappointing 15th at the Association for Intercollegiate Athletics for Women (AIAW) National Championships. Among the Eastern gymnasts competing at the Penn State meet were, from left to right, Julie Winslow, Rhonda Wilkerson, Kathy Goode, Lisa Wray, Laura Spencer, Miriam Naylor, Cheryl Behne, and Beth Miles. (Courtesy of Women's Gymnastics Program Records, EKU Archives.)

According to the 1984 *Milestone*, Eastern's "electrifying eels shocked their opponents this year with one of their most successful seasons in recent history." The team is seen here in action at a January 1986 dual meet. The team finished the season at 8-3 and set 15 school records in 12 different events.

In his first year as head coach in 1975, Jim Suttie (second row, far right) led his team to the OVC Golf Championship. That season, Eastern's golfers also won the EKU Invitational twice and the Colonel Classic. Three players were named to the All-OVC Team, including Roc Irey (second row, far left), Bob Holloway (second row, third from the left), and Chuck Irons (first row, second from the left).

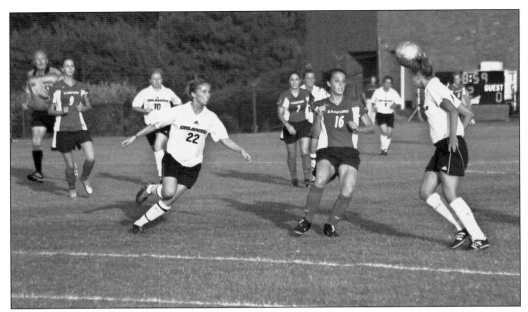

In this 1-0 game against Samford on September 23, 2005, Eastern player Wendy Hoots can be seen heading the ball. Other Eastern players clearly visible are Jenna Harris (10), Janine Davie (22), and Lindsay Prutsman (8). This game was the bright spot in a disappointing first season for the EKU Women's Division I soccer team.

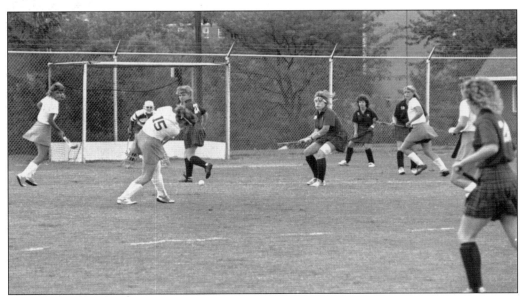

In this October 11, 1986, photograph, Karen Tatum (15) is attempting to score against the University of Louisville. From 1928 to 1970, field hockey was an intramural sport for women. Field hockey had been a recognized intercollegiate sport since 1971, and by the time of this photograph, women were receiving scholarships to play.

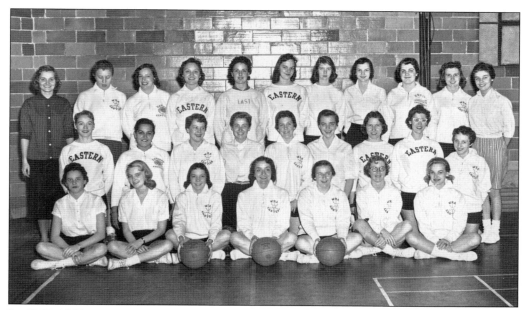

In 1957–1958, women's sports were still intramural and only included two sports, field hockey and basketball. This may explain the size of the team—25 players and 2 instructors. Carol Kidd (third row, far left) and Dorothy Quisenberry (third row, far right) both taught in the Health and Physical Education Department.

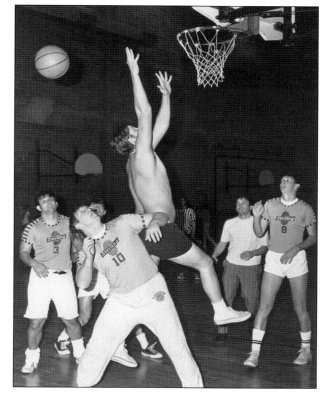

Intramural sports have always been a part of campus life. When this 1969–1970 intramural basketball game was photographed, the *Milestone* reports that Eastern's intramural program was divided into two divisions, fraternity and independent. The crowning of a campus-wide champion was the highlight of the intramural year.

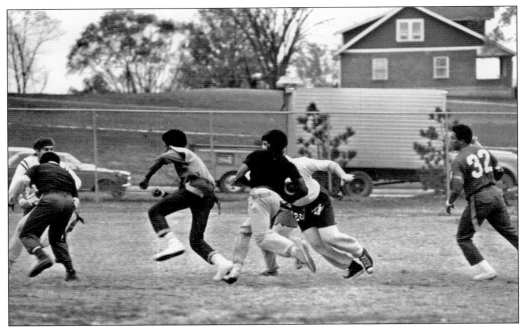

Another popular intramural sport for men in the late 1960s and early 1970s was flag football. In this November 1969 photograph, the 7-11 team shows the fancy footwork that won them the Independent League Championship that year. This was an 18-13 victory over the Tomatoes.

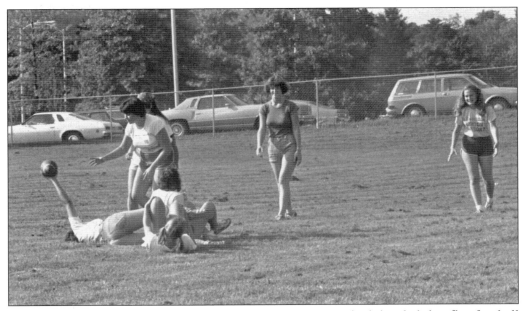

By September 1978, as demonstrated in this image, women had decided that flag football just was not rough enough. They are engaged in a good old-fashioned game of tackle!

Five

MODEL SCHOOL

A crossing guard assists Model Laboratory School elementary students as they cross Lancaster Avenue at Park Drive in January 1976. Keene Hall is visible over the Donovan Building, which houses the Model School. Model Laboratory School is a department of the College of Education and collaborates with the university's education programs to provide an environment where faculty and staff can inspire students by challenging them through traditional and innovative strategies.

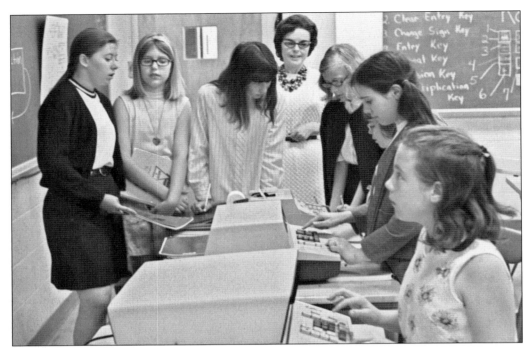

These two photographs provide an excellent example of Model's commitment to innovative strategies. In the last few decades, the school has attempted to keep up with technologies that help prepare students for the world outside. In the January 1969 photograph above, students are learning to use an electronic adding machine, and in the image below, they are seen using the relatively new desktop computers in February 1986.

Foreign languages were being taught to Model first and second graders as early as 1964. In this *c.* 1966 photograph, Juanita Peale is teaching a lesson in French to a group of students.

Debbie Brown is seen in this *c.* 2000 photograph working with Model Laboratory School students. Brown currently serves as the elementary director of the school.

Singer and songwriter Mac Davis entertains a Model elementary class. Davis was on campus October 10, 1974, for a concert performance in Alumni Coliseum with Anne Murray. Tickets for the concert were $2 for students and $5 for non-students.

This May 1980 photograph was taken at History Day. The adult at right is probably a judge for a project that the student at left had on display. History Day is an educational program sponsored by the Organization of American Historians to encourage students in grades 7–12 to prepare projects, papers, and performances on historical themes.

On October 17, 1990, the Model Elementary School held their second "Penny Day" in the gymnasium. Model Parents for Excellence sponsored the event to fund the completion of the new playground. After saving pennies for a week, the students brought them in to be spread out on the floor and counted. They raised $2,200 that day.

"Stop where you are! Drop to the ground and cover your eyes. Roll over and over until the fire goes out. If your clothes catch on fire, 'Stop, Drop, and Roll.' " That is the lesson that these Model nursery-school children are being taught in this October 1980 photograph.

Music has been a part of the Model School experience for much of its history. In this photograph, c. 1965, the Model Junior Orchestra is seen at practice.

Performances of *The Messiah* at Christmastime have been a tradition dating back to the very earliest days of Model School. In this c. 1972 image, four elementary students are dressed as angels.

In 1976, the Model School changed their team name from "Rebels" to "Patriots." In this fall 1971 photograph, the Senior High Band was still using the "Rebels" and flying the Confederate battle flag. The school colors were changed in 1973 from red and grey to red, white, and blue, and in 1975, the students voted to undertake a change in the mascot name. From a 30-name list, they eliminated all but three—Raiders, Patriots, and Generals—and the students voted for "Patriots" by 190 out of 240 votes.

Elementary students are seen here at play on the school playground in October 1974.

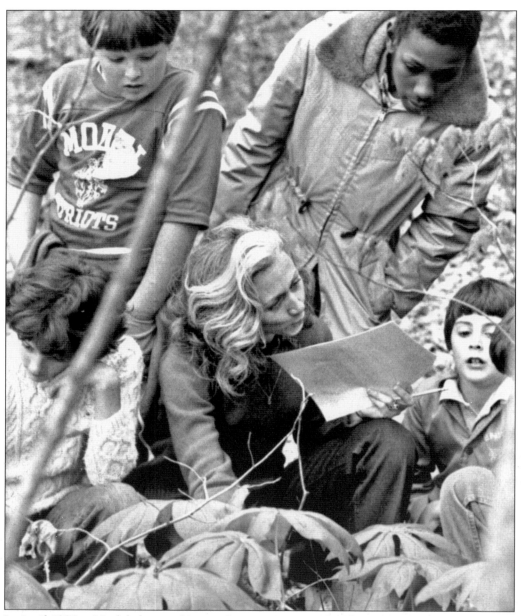

In April 1980, a Model class and its teacher visit Maywoods. The Maywoods Environmental and Educational Laboratory, located in the Knobs of Garrard and Rockcastle Counties, is a 1,700 -acre forested area managed by Eastern as an official state wildlife refuge. Maywoods was purchased in 1973 to be used for research and field work in environmental science and ecology. A 13-acre man-made lake, hiking trails, and a lodge make Maywoods an excellent facility for conferences, workshops, retreats, and a class setting for Eastern and Model classes. The facility is also available for use by other educational institutions. Besides Maywoods, Eastern manages two other natural areas: Lilley Cornett Woods (Letcher County) and Pilot Knob State Preserve (Powell County). The Division of Natural Areas is responsible for coordinating the research, educational programs, development, and use of these areas.

Six

RICHMOND AND MADISON COUNTY

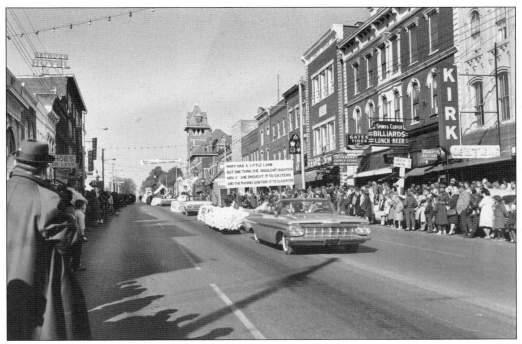

Eastern homecoming parades often are the best source for images of Richmond's Main Street, such as this one from the 1963 parade. The tower of the Federal Building can be seen in the background, and some of the local businesses include Kirk Jewelers, Sports Center Billiards, Richmond Supply Store, and Gates Tires.

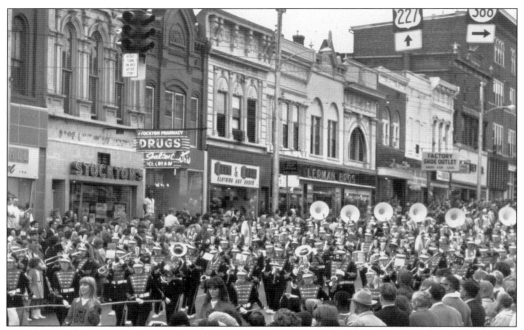

This photograph of Eastern's 1966 homecoming parade shows the stores on the north side of Main Street between Second and Third Streets. Stockton Drug Store served Eastern students for decades; Jett and Hall is still in business a couple doors down, and Lerman Brothers was a major department store.

The intersection of Main Street and Madison Avenue has changed drastically since this 1956 homecoming parade. Alumni from the 1970s, 1980s, and 1990s will remember J. Sutter's Mill where the Kroger store is. Standard Oil has been replaced with the post office parking lot, Texaco is now the Richmond Chamber of Commerce, and Kennedy Produce is now Madison Garden.

The block of Main Street across from the courthouse is another that has changed drastically since 1964, when this photograph was taken. The two buildings on the far right are the only ones remaining today. The Ben Franklin store burned, and the other buildings were replaced with new buildings and a parking lot.

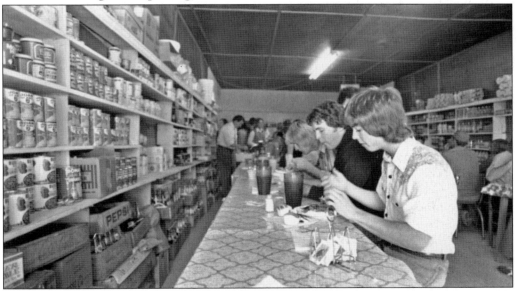

For 30 years, Eastern students, faculty, and staff enjoyed great home-cooked meals at reasonable prices when they ate at Ma Kelly's. The restaurant was not much to look at from the outside, and the walls were covered with graffiti as visitors signed their names when they came in for a meal, but the food was so good everyone came back for more. This photograph was taken in 1978.

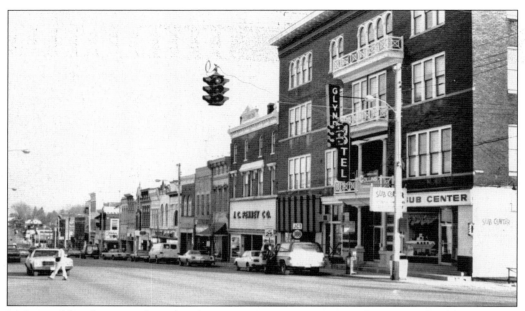

Richmond has been working hard in recent years to renovate downtown buildings rather than destroy them, so even though the stores seen in this 1979 photograph on the south side of Main Street from Second to Third Street have changed, the buildings have been given a facelift. The Glyndon Hotel on the corner, established in 1889, is one of the longest-running businesses in the city.

Here is another shot of the north side of Main Street between Second and Third Streets taken in 1979. Towne Cinema and the furniture store beside it are now a parking lot, and the Richmond Bank Building is now city hall. The clock tower on the courthouse can be seen over the buildings.

Recent changes to Main Street include the removal of all overhead electric lines, which removes some of the clutter seen in this 1975 photograph. Very few of the businesses seen here are still in downtown Richmond. Most have moved to other locations, where they had room for expansion.

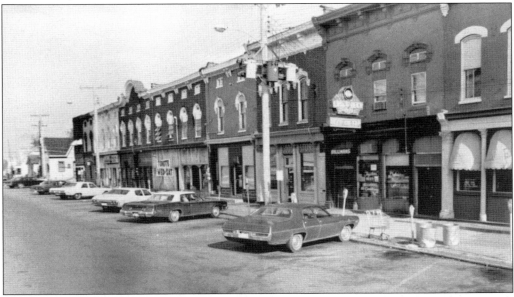

Eastern has had a reputation for being a party school in the not-so-distant past, and this block of First Street across from the courthouse, pictured in 1978, had the largest concentration of bars in town. Business is slow during the day, but on Thursday nights, lines form outside the bars with students waiting to get in. Most of the buildings in this block were built in the 1870s, and most are still standing.

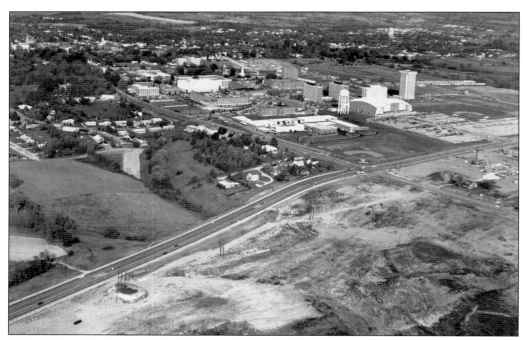

This 1967 aerial photograph of Eastern shows the Eastern Bypass shortly after it was built. Ground has been broken for the construction of Keene Hall and the businesses at the intersection of Lancaster Avenue and the Bypass, but no buildings are there yet.

The Eastern Bypass is not exempt from change. None of the businesses in this 1981 photograph are in this location now except for Arbys. Most have moved to other locations, but some like Hecks and Burger King have gone out of business.

The north side of the Bypass has also changed. Sir Pizza is long gone, Ponderosa Steak House, just past Wendy's, burned in 1991, and the motel is now small storefronts. McDonald's and Wendy's are still on this block but in new buildings. Notice the gas price in 1981.

Looking on out the Eastern Bypass, there are still more changes. Jerry's and the Thrifty Dutchman Motel are gone, and many new businesses have opened and closed since this photograph was taken in 1981. In the past decade, many new restaurants and hotels have opened across I-75, as well as Galaxy Bowling and Entertainment Center.

Lake Reba also has changed since this photograph was taken in the 1950s. In the 1980s, the area was redesigned and made into a city park, with softball and baseball fields, a golf course, a playground, and picnic areas. At the same time, the water treatment plant below the dam was demolished and the dam across the middle of the lake was partially removed. In 2004, miniature golf and batting cages were added. The cornfield in the foreground has been replaced with houses. (Jimmy Taylor Photographs, EKU Archives.)

Just north of Richmond is the site of Fort Boonesborough c. 1974. Named after Daniel Boone, this is the second fort built in Kentucky in 1775. Largely through the influence of Prof. Jonathan T. Dorris and Pres. Robert R. Martin, land was purchased for a state park and a full-size replica of the fort was built. The site includes the largest natural sand beach along the Kentucky River, but the river is no longer open for swimming.

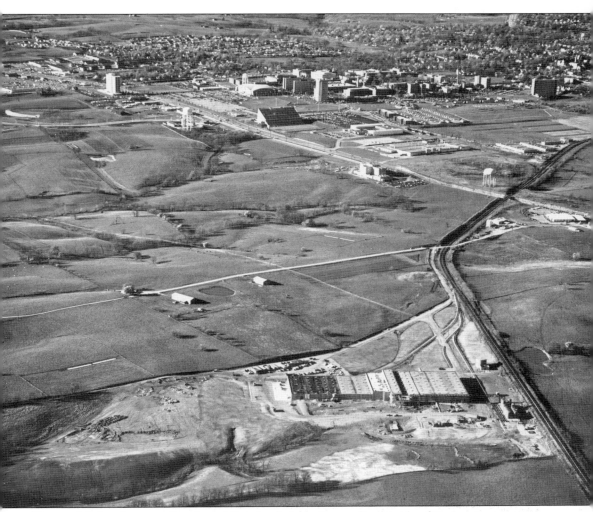

This aerial also shows undeveloped farmland along the southeast side of Eastern's campus in 1976. In the foreground, the Sherwin-Williams plant is under construction. Commonwealth Ford is on the far right, and the Pattie A. Clay Hospital is near the center of the photograph. The hospital has since added three additional buildings. Lowes and Wal-Mart are now on the land at the bottom left-hand corner of the photograph. Other businesses built just above Sherwin-Williams include the Richmond Recycling Center, the Richmond Skate Center, and Hinkle Block and Masonry. Various other buildings and warehouses dot the landscape around the railroad tracks. The most recent addition is the new soccer field and locker room built for Eastern's new women's team right beside the hospital.

APPENDIX

EASTERN PRESIDENTS

Ruric Nevel Roark (1906–1909)
John Grant Crabbe (1910–1916)
Thomas Jackson Coates (1916–1928)
Herman Lee Donovan (1928–1941)
William Francis O'Donnell (1941–1960)
Robert Richard Martin (1960–1976)
Julius Cherry Powell (1976–1984)
Henry Hanly Funderburk Jr. (1984–1998)
Robert Walter Kustra (1998–2001)
Joanne K. Glasser (2001–Present)

SCHOOL NAMES

Eastern Kentucky State Normal School (1906–1922)
Eastern Kentucky State Normal School and Teachers College (1922–1930)
Eastern Kentucky State Teachers College (1930–1948)
Eastern Kentucky State College (1948–1966)
Eastern Kentucky University (1966–Present)

A Vision for the Future

As Eastern Kentucky University proudly reflects on the tradition of excellence established during her first "Century of Opportunity," she also boldly embraces ambition, with a strong resolve to build on our reputation for academic excellence, serve the Commonwealth in new and exciting ways, and achieve even greater national distinction in the years to come.

As you rekindle fond memories of your time on the Campus Beautiful or learn more about our storied past through this pictorial history, my wish is that you'll be inspired anew to help the university fulfill its mission as a "School of Opportunity" and make dreams come true for generations of EKU students to come.

The spirit that has shaped and stirred this great university these past 100 years, the passion for life and learning captured so vividly on these pages, is the same force that will carry us forward to even greater success and prosperity in our second "Century of Opportunity." We appreciate your presence and your support on the journey.

—Joanne Glasser
President, Eastern Kentucky University

Pres. Joanne Glasser poses with several Eastern students in 2005. From left to right are (first row) Sachin Pandey (Nepal), Kacy Cluxton (Manchester, Ohio), Pres. Joanne Glasser, Stacy L. Cluxton (Manchester, Ohio), and Mariko Yamakura (Japan); (second row) Stephanie Manning (Williamsburg, Kentucky), Kristin Kissinger (Williamsburg, Ohio), John Paul Ramsay (Berea, Kentucky), Adam Curry (Richmond, Kentucky), Kelly Baumer (Edgewood, Kentucky), and Richard Yongbang (Cameroon). Buildings in the background include Burnam Hall (left) and the Keen Johnson Building (right).

CROSS AMERICA, PEOPLE ARE DISCOVERING SOMETHING WONDERFUL. *THEIR HERITAGE.*

Arcadia Publishing is the leading local history publisher in the United States. With more than 3,000 titles in print and hundreds of new titles released every year, Arcadia has extensive specialized experience chronicling the history of communities and celebrating America's hidden stories, bringing to life the people, places, and events from the past. To discover the history of other communities across the nation, please visit:

www.arcadiapublishing.com

Customized search tools allow you to find regional history books about the town where you grew up, the cities where your friends and family live, the town where your parents met, or even that retirement spot you've been dreaming about.